Introduction

The Cathedral City of Ely, on the River Great Ouse, is a rapidly expanding market town with a population near to 20000. Situated on a low hill the Cathedral, visible for miles across the surrounding flat fen countryside, continues to provide both a focal point and a splendid backdrop to views of the city as it has for over eight hundred years. The medieval precincts of the former monastery, with the streets and buildings that form the heart of the city, reflect its continuity and stability.

This collection of Ely photographs attempts to show the different changes and developments that have taken place mainly during the last sixty years, though some reflect earlier change. The new ones are tomorrow's history.

During the 1960s probably the biggest change for over 150 years occurred when buildings on the Market Place, that included the nineteenth century Corn Exchange and the Public Room (Exchange Cinema), with adjoining buildings, was demolished. They were replaced with what is generally agreed to be a banal, undistinguished block of shops. Parking was banned on the Market Place when it was repaved with pink bricks in the 1990s and later part of the north side of the Market Place was pulled down to make way for the entrance to The Cloisters, a new shopping area. Recently a large new Arts Centre has been completed between The Gallery and Church Lane for the King's School, Ely's public school.

Since the middle of the nineteenth century most of the premises occupied by shops have remained the same though retailers have changed, in some cases, several times. The rapid closing and re-opening of shops has been particularly noticeable during the last two years. In the city centre changes to existing buildings have been relatively small; for example on the north side of the High Street two windows on one building have been changed, the front of what was once Cutlack's

rebuilt and further down Peck's unusual bay window removed. In the city centre many small gaps have been filled and in others small groups of houses built. There have also been larger developments, for example Cardinals Way between Broad Street and the river where there was once a large garden, then a small industrial development, followed by Ely's second Tesco. Another example is John Amner Close and streets beyond, off the Lynn Road. In other places buildings have been demolished, then replaced with a higher density of houses as, this year, in Church Lane. The largest new residential development lies around the outskirts to the west and north.

The proportion of long-term residents and those born here has decreased markedly as the population has grown. The amount of road traffic has increased. Nevertheless, at times Ely is still a quiet city, but on Market days and at the weekends is bustling with many shoppers, visitors and tourists.

Whatever the changes the essential heart of the city remains today.

ELY
THROUGH TIME
Pamela Blakeman

AMBERLEY PUBLISHING

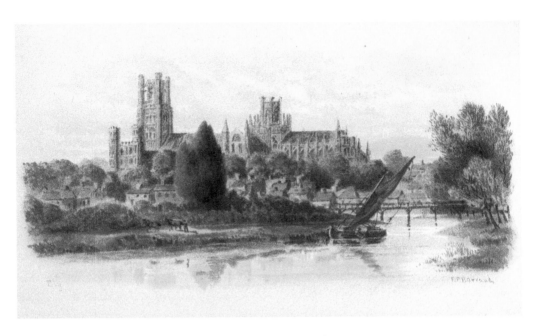

Ely Cathedral with the River Great Ouse in the Foreground
This lithograph by P. B. Borraud, 1887, shows the towpath, the early railway bridge and, on the right, 'across the water', part of Babylon. The bridge was replaced in the early hours of a Sunday morning in 1896 when it was said to 'have been a great engineering feat' due to the speed with which the work was done. It is still in regular use on the Ely to Norwich, King's Lynn and Peterborough railway lines.

First published 2010

Amberley Publishing Plc
Cirencester Road, Chalford,
Stroud, Gloucestershire, GL6 8PE
www.amberley-books.com

Copyright © Pamela Blakeman, 2010

The right of Pamela Blakeman to be identified as the Author of this work has been asserted in accordance with the Copyrights, Designs and Patents Act 1988.

ISBN 978 1 84868 530 7

British Library Cataloguing in Publication Data.
A catalogue record for this book is available from the British Library.

Typeset in 9.5pt on 12pt Celeste.
Typesetting by Amberley Publishing.
Printed in the UK.

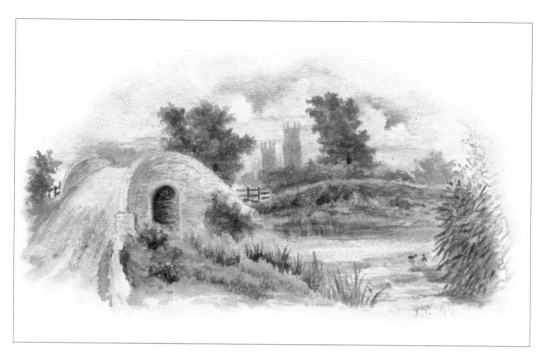

Cuckoo Bridge; Watercolour by local artist John Titterton 1889

Once used by workers walking to the beet sugar factory at Queen Adelaide, Cuckoo Bridge is about a mile from the city centre. The stone bridge survived until about 1940 but when water levels were high barges could not get under it to enter the Roswell Pits area. Two successive wooden structures replaced the early bridge until, in 2000, a more permanent one was built at a cost of £90,000 and was officially opened 26 January 2001.

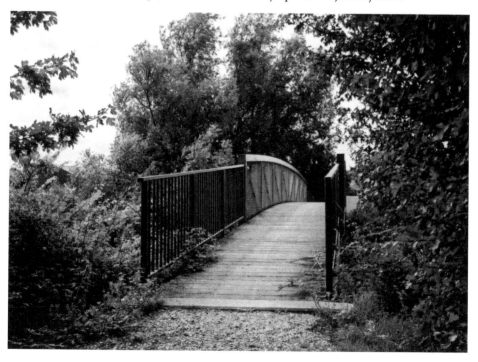

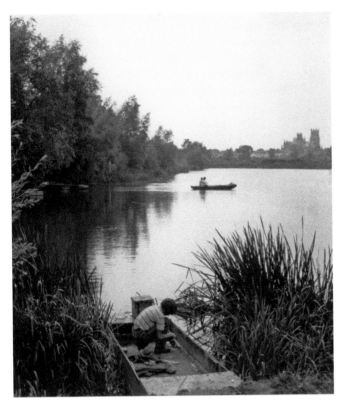

Roswell Pits

The 'Pits' were formed when, for over 300 years Kimmeridge clay was dug out to build up the river banks so that, except in unusual circumstances, flooding of surrounding low lying farmland was prevented. Since 1946 headquarters for Ely Sailing Club have been here. The pits are also a refuge for wild life and fishing, recently Bitterns have been seen here and nearby. Proposed drastic changes were abandoned when the area was made one of Special Scientific Interest in 2009.

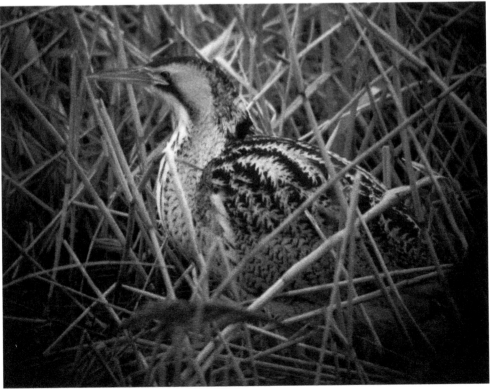

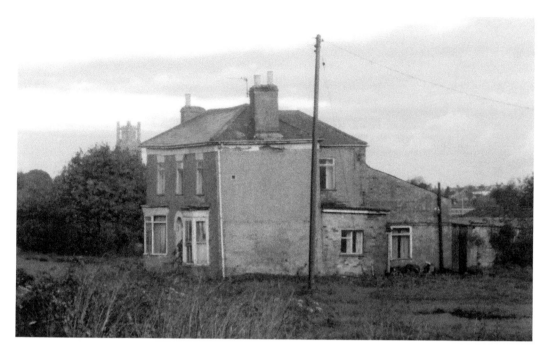

Laburnam House, Stuntney Road

Architect Graeme Lockhart bought the derelict nineteenth-century Laburnam House, on the corner with Queen Adelaide Way, when he realised that here his desire to build a home 'kind to the environment' might be possible. Two years later, in 2008, he and his wife moved in; he works surrounded by wonderful views of the Cathedral and the fens seen through his office windows. As the site is unstable fenland the house is built on twenty-six twelve metre concrete piles.

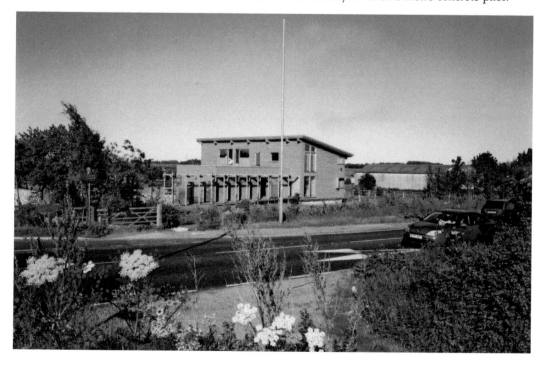

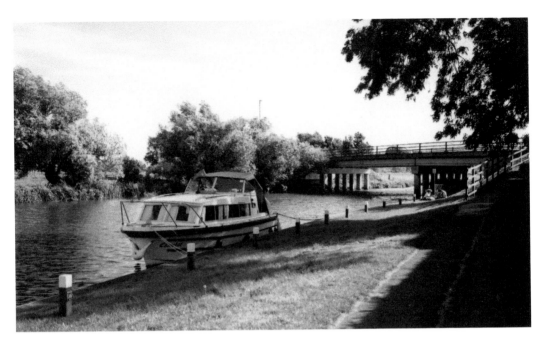

Ely High Bridge over the River Great Ouse
The older bridge, opened in 1910, replaced the one of 1833; it was constructed by Alex Findley & Co. of Motherwell. The present one was built on the site of the 1833 bridge and opened in 1982. A bridge here has for long been an essential part of the route into Ely from the Newmarket direction. Celia Fiennes approached Ely along this causeway in 1698 on horseback – 'Ely looke finely through those trees (willows), and that stands very high'.

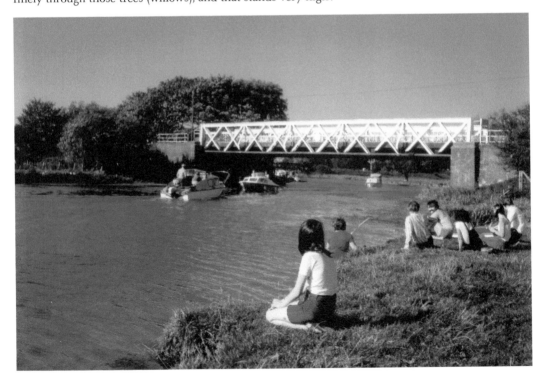

The Towpath on the West Side of the River

Formerly a rural place for picnics this towpath, along the west side of the river, has changed slowly and is now relatively urbanised with safety railings and leisure boats moored along the embanked sides. Until the latter half of the last century the path was frequently flooded in springtime, the water often reached into Cutter Lane and Victoria Street. Further 'cuts' to carry floodwater to Denver Sluice have, for the present, brought an end to this once regular inundation.

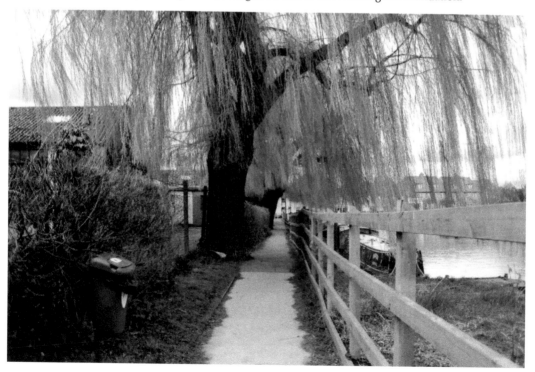

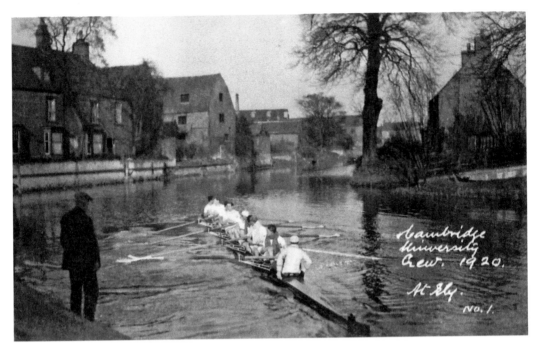

Cambridge University crew in 1920 and the King's School

The Cambridge Boat race crew has practised here for many years but the most frequent oarsmen – and women – today are members of the Kings' School, Ely's public school. In the distance the Cutter Inn and Steward's Maltings; on the right Babylon, where Cambridge University and the King's School each have a boathouse. The recent photograph was taken from a different angle to show the two boathouses on Babylon.

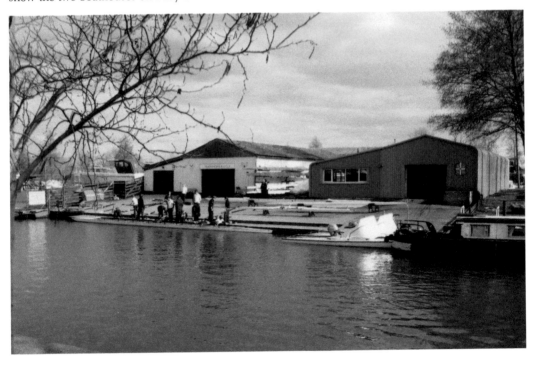

The Cutter Inn and Aquafest

The Cutter Inn was named after the cutters who worked on the 'New Cut' that shortened the route to Littleport. The earlier picture shows the chain ferry that ceased to be used soon after 1964. The Riverside Walk, on the right, was officially opened 1968. Here new houses, facing the river have replaced the wall. In 2009 Aquafest, a fun event staged by Ely Rotary Club for charity, has taken place annually since 1977.

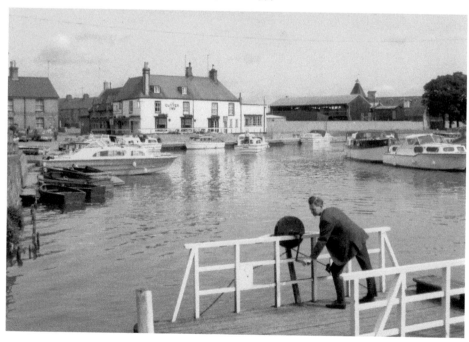

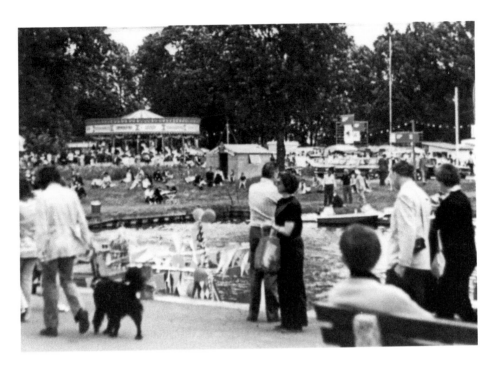

The Thirteenth Centenary Celebrations 1973

The foundation of the monastery at Ely in 673, by St. Etheldreda, was marked by a great many memorable festivities held throughout 1973. Babylon, where local families lived as early as the thirteenth century, can never look the same again since today it is almost entirely occupied by a marina. There are moorings for 250 boats but it is not possible, in one photograph, to give an adequate idea of its size.

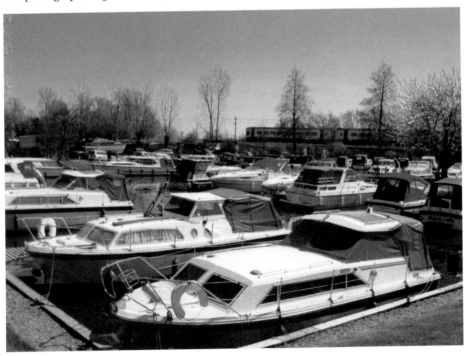

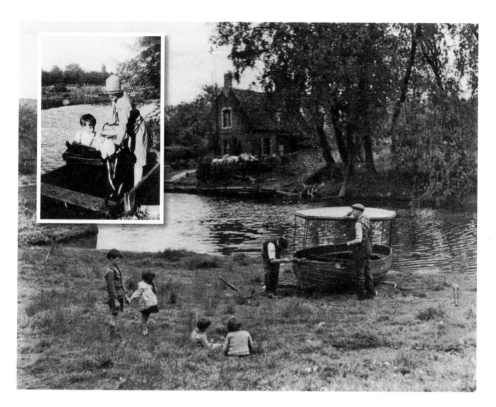

The Quay near Waterside

Nearby were once a number of hythes where goods of all sorts, including stone for the Cathedral, were landed. Ted Haylock, well known Ely citizen, for over twenty years churchwarden at St. Mary's Parish Church, is cleaning his boat at the quayside in 1939. The Lincoln Bridge which leads to Babylon was built 1964. The inset shows an earlier way to get to the houses on Babylon that were occupied until the late 1920s.

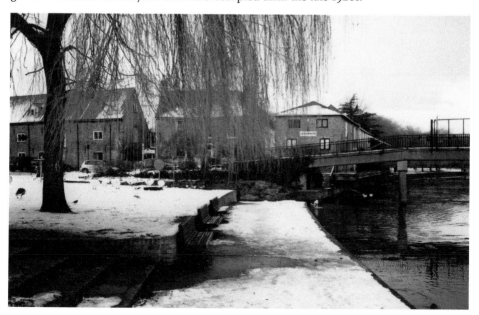

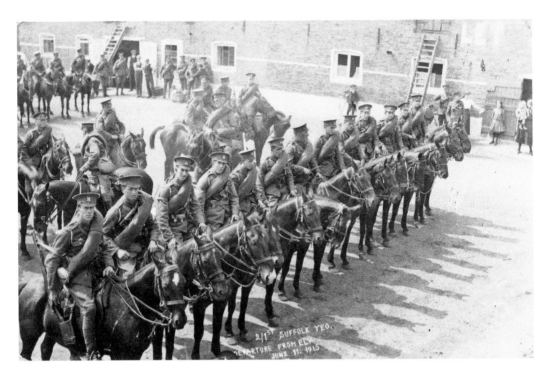

The Suffolk Yeomanry

'The 2/1st Suffolk Yeomanry departure from Ely June 11, 1915'. On this west side of the river near Annesdale an old granary, certainly there in the 1850s, is in the background. In 1977 this was replaced by three-storey town houses that have interesting views from the top floor windows of that part of Ely and the river.

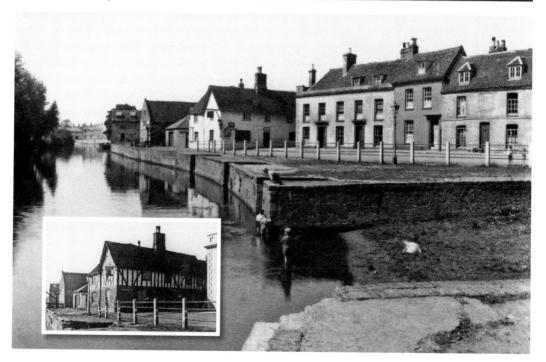

The Quay, Ship Inn;
The Maltings in the background.
The Ship Inn as it was before the
Second World War with houses,
recently restored, on the corner of
Ship Lane. After the war The Ship
changed; with the use of concrete,
it was given a mock Tudor
appearance. The inn closed in
1955 and was demolished by 1961;
the crane is now on the opposite
side of the river. A second large
willow tree, behind the one
shown, was taken down following
storm damage on 13 November
2009 and replaced.

Station Road looking toward Ely and the Cathedral

Travellers saw this Edwardian view after 1845 when the railway came to Ely. This was also the route followed by travellers along the Causeway from the south. Once plane trees, replaced by other trees, ran alongside the station goods yard on the left until 1994 when Tesco opened. Public houses on the right, in the older picture are, King Charles in the Oak, The Railway Tavern and The Crown where there is now a garage and Standen Engineering Ltd.

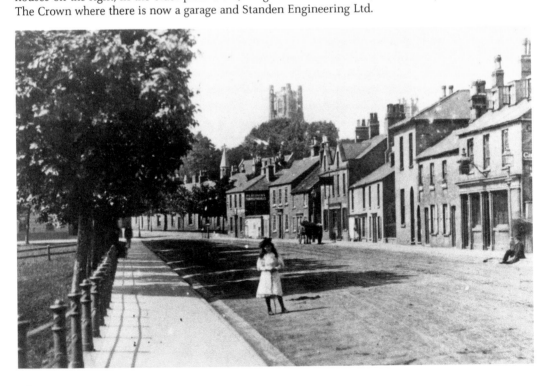

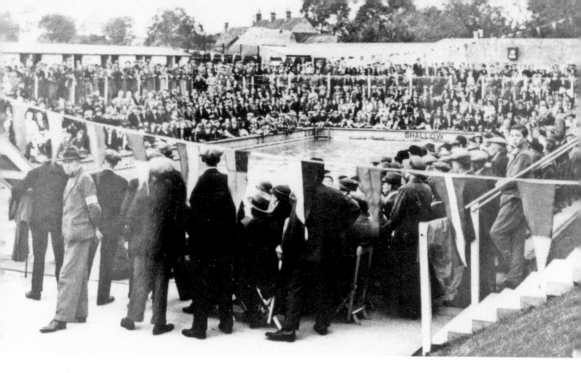

Ely Swimming Pool, opened 1934

The river had for long been the venue for swimmers until this pool, near Angel Drove and not far from the gas works, was officially opened on 22 July 1934; it was closed by 1980. A new pool was opened in 1981 on Paradise Field. Houses and a garage on Angel Drove have replaced the 1930s pool which had been the scene of many galas and enjoyable events.

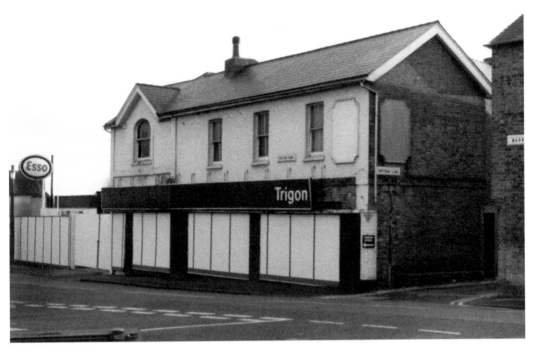

Trigon on the corner of Potters' Lane and Station Road

Here was the Black Swan public house for at least two hundred years until it closed in 1951. Slightly further south east was Ely Light Co. opened in 1835 and, after many changes of name and ownership, gas production ceased in January 1957. The site was then occupied by Graven and Son's car showrooms followed by Trigon (Ford). This in turn closed and, eventually, the buildings were demolished and eight three-storey houses built in 1995.

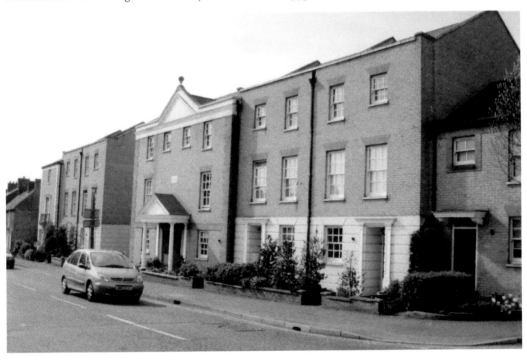

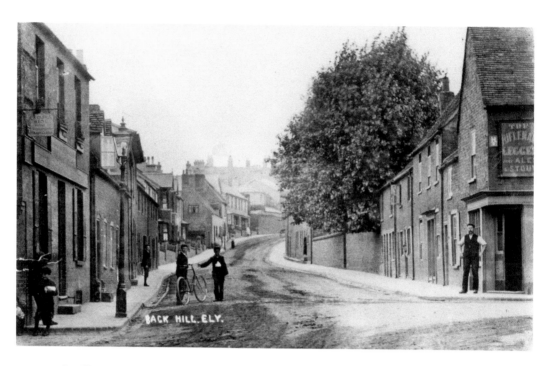

Back Hill

About halfway up the hill, on both sides, houses have been demolished and replaced with new ones though much has not changed, except on the corner with Broad Street, at the bottom of the hill. The shop, formerly The Rifleman, has been replaced with trees, flower beds, and two adjoining cottages on Back Hill have lost their traditional appearance. The corner, taken from the north side of Back Hill, shows some of these changes.

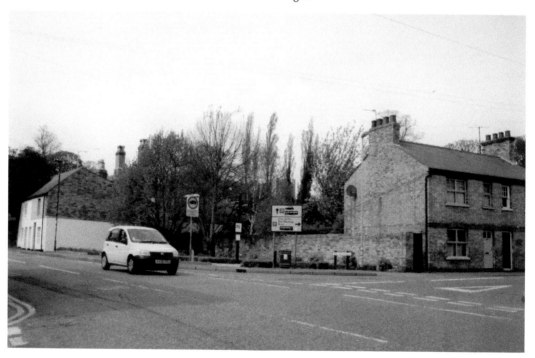

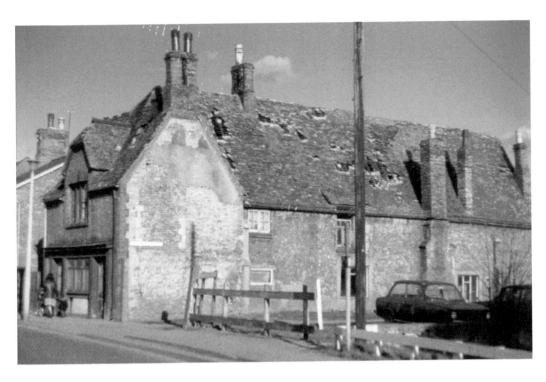

The Three Blackbirds

The former merchant's house, later a public house, in Broad Street, was partitioned to form separate units after the public house shut in 1932. Later the property had to be closed due to its dilapidated state. After attempts to sell, a company eventually bought and re-roofed the building. Ely Preservation Trust then purchased the property, and when research and restoration were completed in 1984, three units were offered for sale. Note too the changed position of the road.

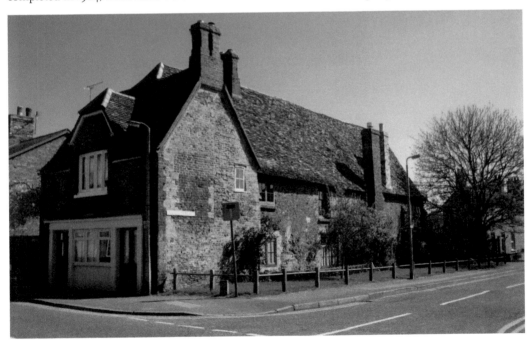

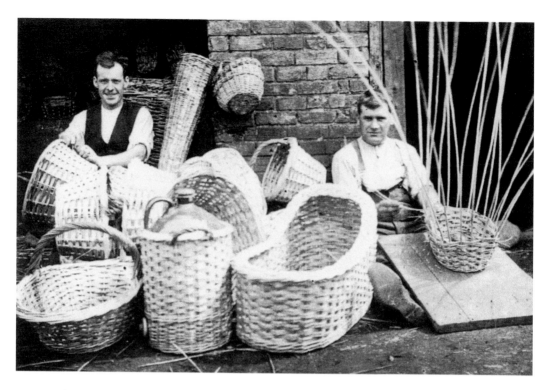

Basket Making

Near the river end of The Three Blackbirds site was Fear's rod yard where osiers, grown at nearby holts, were landed for making into a variety of baskets chiefly for agricultural use. Ely had a thriving basket making industry in the nineteenth and part of the twentieth century; baskets were sold locally and at Bury St. Edmunds market. Today, one of Ely's profitable industries is technology at the Cambridgeshire Business Park to the south, beyond Tesco, on Angel Drove.

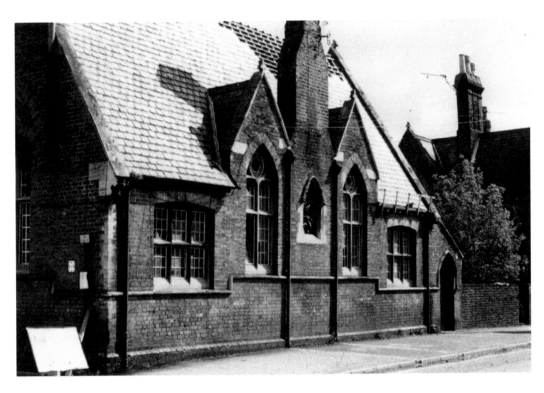

Broad Street School

The school, on the corner of Ship Lane was, at different times, for infants and for juniors. It was built by Samuel Saunders Teulon in 1859 as was the teacher's house on the right of both photographs. The school closed in 1968 and was used by Ely Pottery until 1981 when it was seriously damaged by fire. The new premises have housed a variety of retail outlets and in 2009 Morlands Antiques moved here from the Market Place.

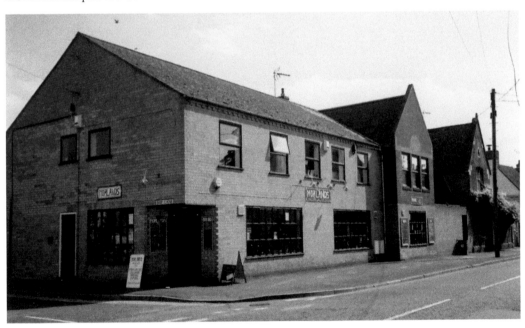

Jewson's and the Jubilee Gardens in Broad Street

In the 1930s, to widen the woodyard entrance, three Tudor cottages were demolished. Owners and frontages changed several times before, about eleven years ago, the firm moved to Angel Drove. The City of Ely Council took the opportunity to provide a new amenity, Jubilee Gardens, to link Broad Street and The Park with the river. Officially opened by the Duke of Edinburgh on 11 February 2002 the gardens flourish and provide a venue for many concerts and other events.

Mr W. P. Snell and Missin Gate

In the nineteenth century W. P. Snell grew arum lilies in his greenhouse on Broad Street; his florist shops were next door and at Steeple Gate until the 1940s. Missin Gate, named after one of the developers, consists of a small group of houses and flats, typical of many off street developments in recent years. Other examples are Engine Yard off St. John's Road, Baker's Corner off Chiefs Street and earlier, John Amner Close off Lynn Road.

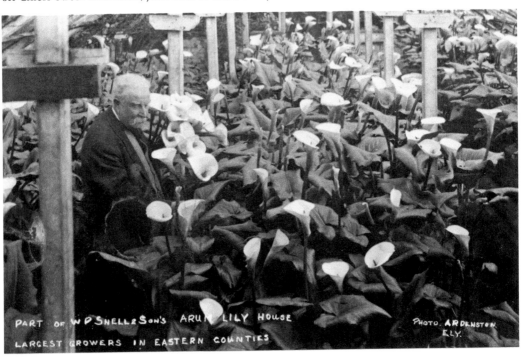

PART OF W.P. SNELL & SON'S ARUM LILY HOUSE
LARGEST GROWERS IN EASTERN COUNTIES
PHOTO. ARDENSTON. ELY.

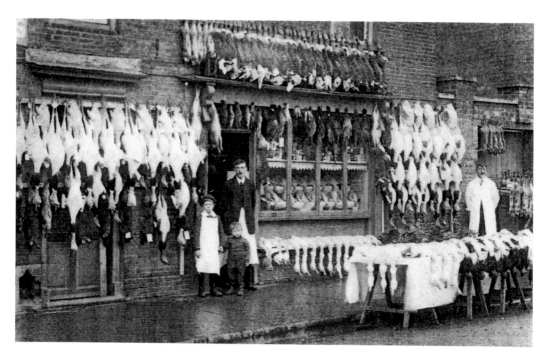

Martin's Shop in Broad Street

Martin's shop, later Newman's, then Richardson's greengrocer's was in Broad Street next to entrance gates to the orchard that flourished to the rear of a large part of Broad Street. Shops and buildings were demolished to make way for the road into the Broad Street/Forehill Car Park, opened in 1965, and for a small office block. The car park was extended the following year. The recent view, taken from the back of the office, shows the busy car park.

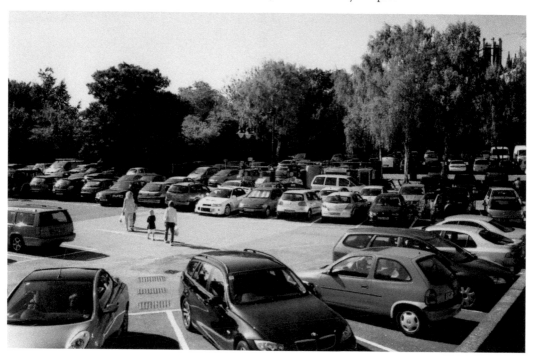

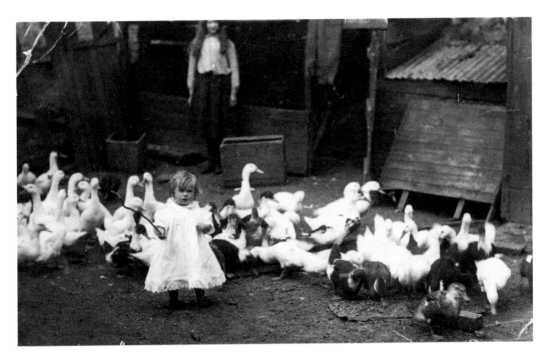

Martin's Duck Farm

Martin's Duck Farm was probably at the back of the shop. The recent view, from the car park, is to houses built on the east side of Broad Street now Cardinals Terrace, the first completed early in 2001. With Cardinals Way these houses replaced Tesco which in 1982 had replaced a small post Second World War industrial site. Until then the large garden to Brewery House, near the river, was here, part of the garden wall is still nearby.

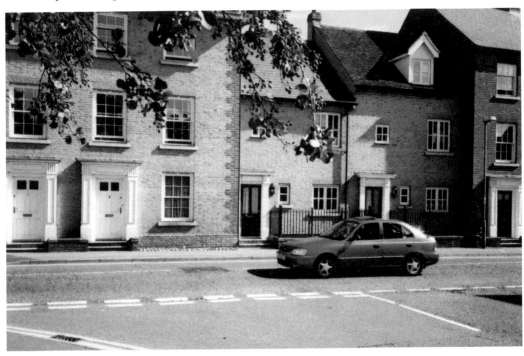

T. Blakeman & Son, Curriers and Leather Merchants

The entrance to the factory was on Broad Street, with a shop and house in Fore Hill (Tom Bolton photographer was next door). The business flourished during the First World War but by the time Thomas Blakeman died in 1944 trade had declined. Later this property, with other buildings, was sold to developers and demolished in 1973. The site of the factory is now the car park for the office block on the corner, seen here from the car park.

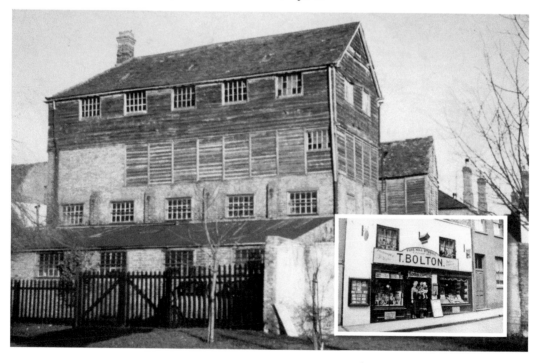

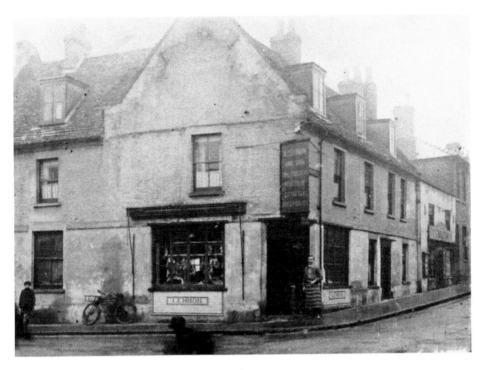

A. C. Lemmon, Butcher and Tom Bolton Photographer

Lemmon's may have first opened in premises in Broad Street, later Martin's, Newman's, etc. By the time Lemmon's on the corner of Broad Street closed in the mid 1950s this, the largest of the firm's two premises, had been open for at least forty-five years. Since 1975 a patch of grass, a willow tree and part of Kingfisher House have occupied the site. Photographer Thomas Bolton's premises can just be seen on the right and in the inset to the previous picture.

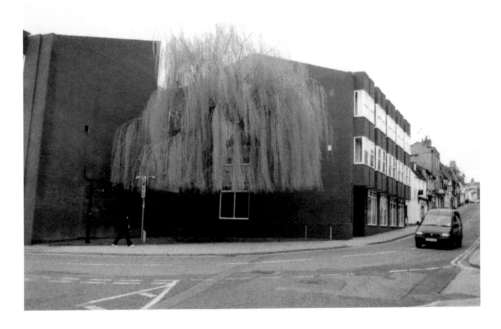

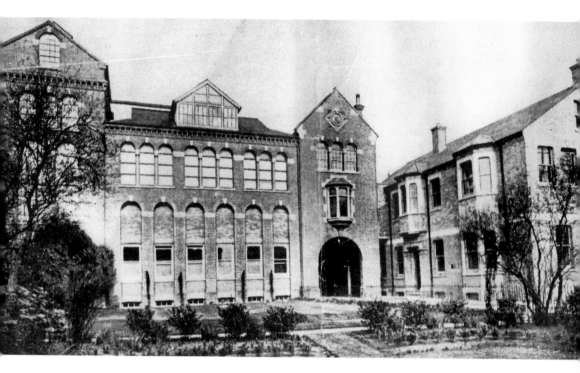

Hall, Cutlack and Harlock's Fore Hill Brewery

This brewery had an imposing entrance that faced down Broad Street with a clock over the entrance, clearly an important workplace in a small town. After several changes of ownership from Hall, Cutlack & Harlock in the 1930s to East Anglian Breweries Ltd. and finally Watney Mann (East Anglia) Ltd. This brewery closed in 1969. Old Brewery Close was built on the site; this new group of houses is at the back of the former brewery premises.

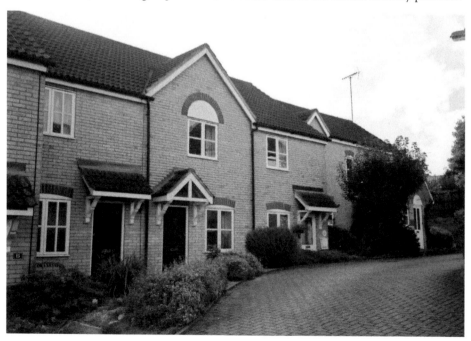

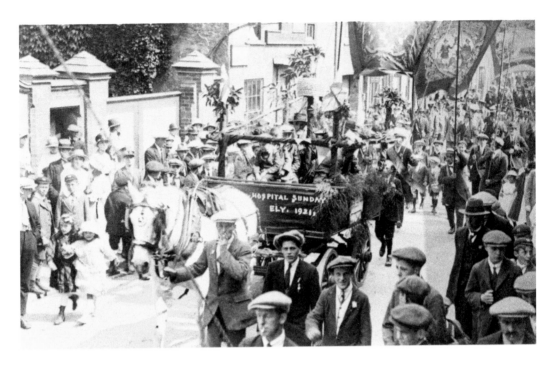

Hospital Sunday 1921

For many years a procession of decorated floats raised money for Addenbrooke's Hospital Cambridge, and for a convalescent home at Hunstanton. Here it is passing by the earlier brewery gates with, to the right, the Round of Beef public house that closed in the 1930s. A notice on the wall reads 'The use of traction Engines on the hill is Prohibited'. More recent gates seen from the site of the Glaziers' Arms have survived the loss of the brewery complex.

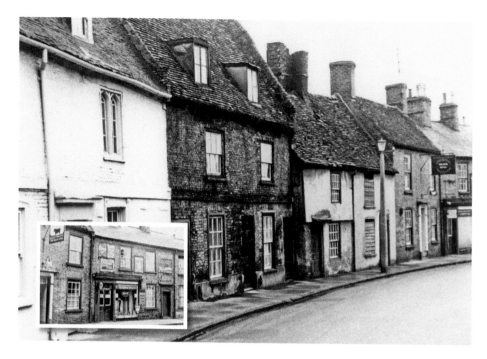

Down Waterside

When the majority of important visitors, tradesmen, pilgrims and others came to Ely by water, this was, for many hundreds of years the most important route to the centre of Ely. After a period of neglect during the first half of the last century it has once again become a fashionable residential area. Ely Boat Chandler's now occupy Monty Fielding's general store, seen on the far right, and inset, which was open from the 1930s until the mid 1950s.

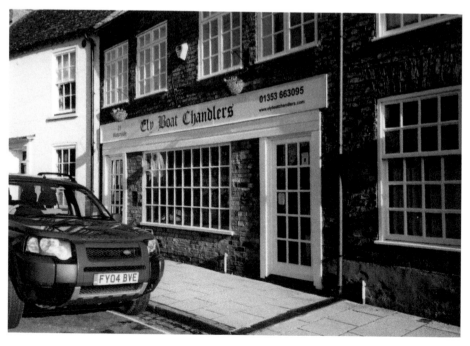

Up Fore Hill, toward the Market Place

On the left is the former Rose and Crown, later Spice City (closed January 2010) and then Gallery Frames. Against the sky a sign advertises 'Ye Olde Tea Rooms', owned at the time by Vernon Cross, master baker, ventriloquist, thespian, councillor and collector of local memorabilia. Those premises are now part of the Royal Standard. On the right is the former Conservative Club; note the changes shown in the next recent photograph; in 2010 further alterations were made.

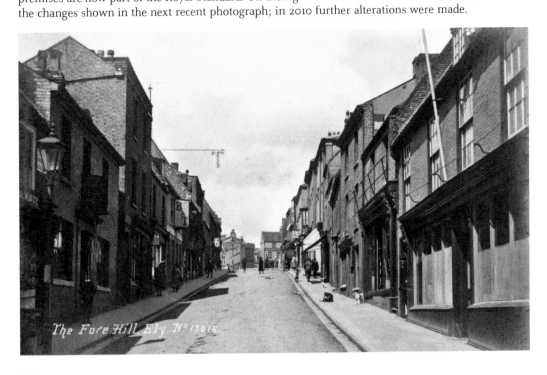

The Fore Hill Ely No 13016.

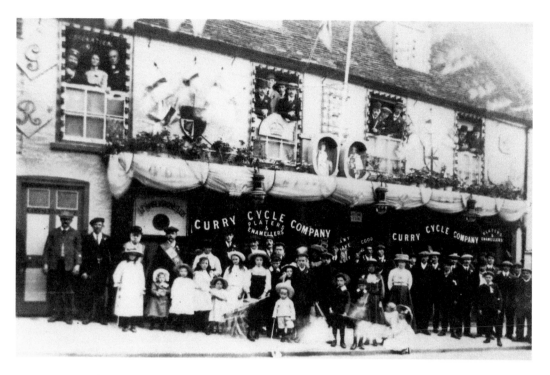

Curry Cycle Company

The premises decorated for the Coronation of King George V and Queen Mary in 1911, when the Conservative Club was probably on the first floor. Curry's moved to the High Street, next to the Bell Hotel; the Conservative Club eventually occupied the whole building. It was sold in 1989 and now houses Ely Spa. The Bell Hotel surrendered its licence May 1960. Curry's then extended to include the ground floor of the former hotel but closed early in 2010.

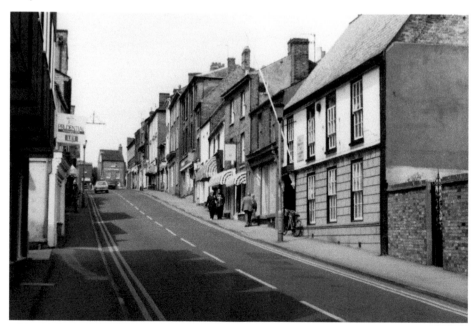

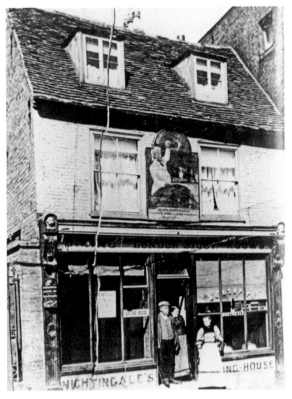

Nightingales Eating House
on the north side of Fore Hill
In the mid nineteenth century this
was, for about a hundred years,
also the Baron of Beef. When J. M.
Evans, gentlemen's outfitters, was
about to move from Broad Street this
property unfortunately collapsed.
After much work Evans opened in
1959 and traded until 1999. For about
seven years Griffin's Antiques shop
was here, to be succeeded by DKW
Fashions (children's and babies'
clothes). Lower down, in place of
Kate Wood's shop and house, is a
small garden.

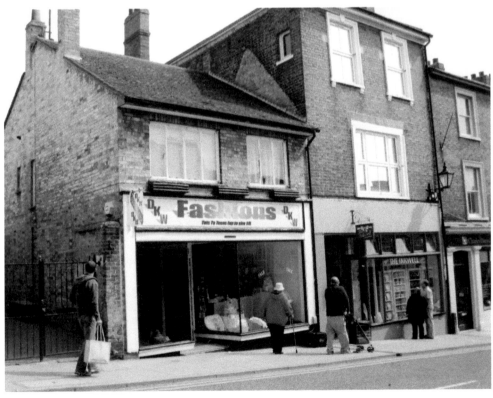

Down Forehill toward Waterside

On the left was a concrete phone box – later three red caste iron kiosks – and the fountain that marked Queen Victoria's 1897 Jubilee. Contrary to earlier reports this was moved to Archery Cresent in about 1950. Haylock's shoe shop was on the corner, now a travel agents, on the right the former Three Cups public house, Hepworth's and Morriss'. Below, Woolworths, (now a £ound Superstore), had not opened so the early thirties photograph shows glimpses of older buildings.

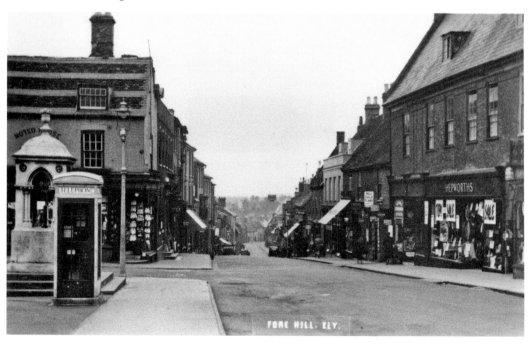

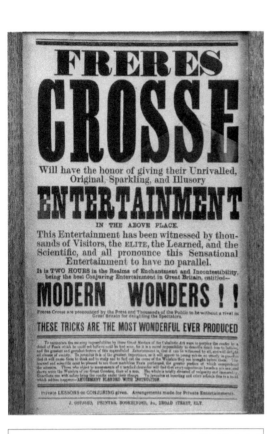

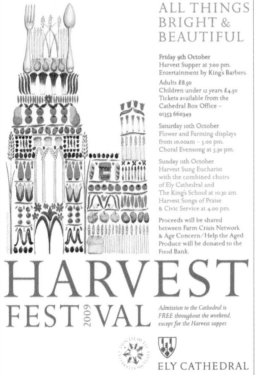

Posters

The older, undated, poster is thought to refer to members of the family of bakers who, at one time had a shop in Broad Street; the printer was J. Gotobed of Broad Street, Ely. Were the two Cross brothers father and uncle of the late Vernon Cross? The modern poster was designed by Lisa Gifford for a Harvest Festival in 2009.

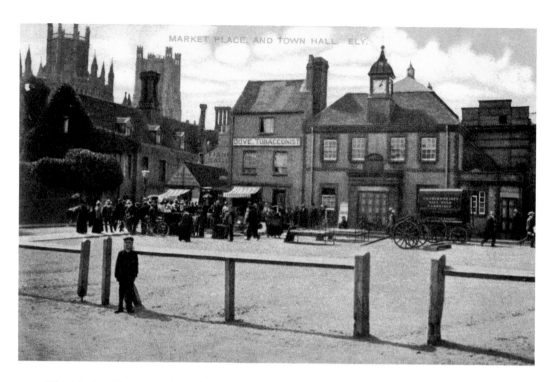

The Market Place and the Public Room

The three-storey house has remained unchanged since the early nineteenth century. The Public Room, later The Exchange Cinema (closed 1963) was on the site of the Sessions House from which the five Ely and Littleport rioters were condemned to death in 1816. On the right is the side of the 1847 Corn Exchange which, with the cinema, was demolished in 1964 to be replaced by two storey flat-roofed shops.

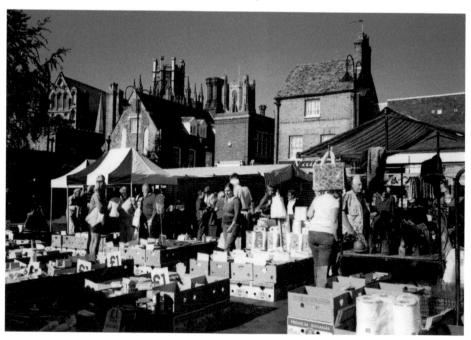

The Market Place War Memorials

The first memorial to local servicemen who died during the First World War was a temporary wooden one dedicated in 1919. The present memorial was unveiled 30 April 1922 and records 308 names of men killed in both world wars. In 2009 a plaque was added 'In Memory of the Fallen from 1945 to the Present Day'.

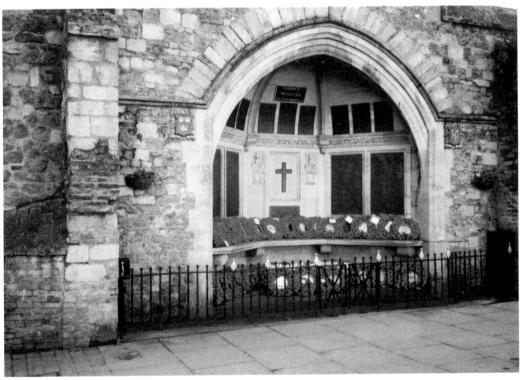

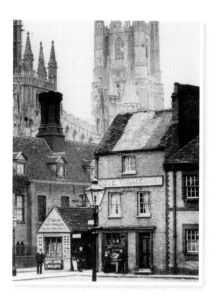

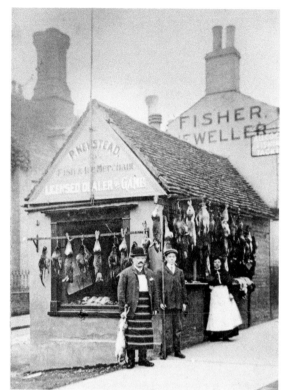

'P. Newstead Fish and Ice Merchant
Licensed Dealer in Game'
In 1899 James Frederick Burrows,
Newsagents opened in this tiny shop.
Earlier Newstead's was here before a
move to the east side of the Market
Place next to Kempton's. The business
closed in 1970 after eighty-three years
of trading. The small premises were
extended to two storeys and became
part of Fisher & Co. Jewellers, now
F. J. Zelly (Ely) Ltd., also jewellers.

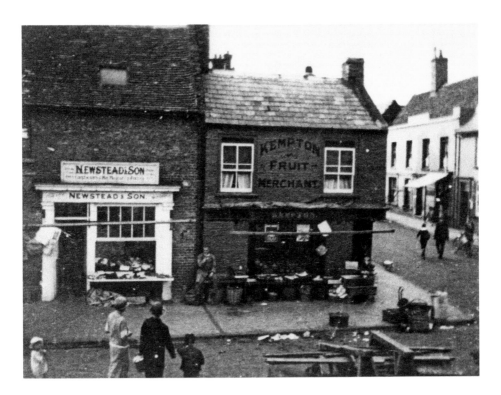

The corner of Dolphin Lane and Market Street

Kempton's Fruit Merchants had been in business here since the sixteenth century. The corner was rebuilt 1936 and Kempton's still traded under this name until the 1970s. Newstead's is shown before a move slightly to the south in about 1930. By then the 'Co-op', later Homemaker, in the large building on the right, had opened (closed in 1980s). The later picture shows the Lunch Box and, above the 1960s shops, the top of flats, completed 2001, between High Street and Market Street.

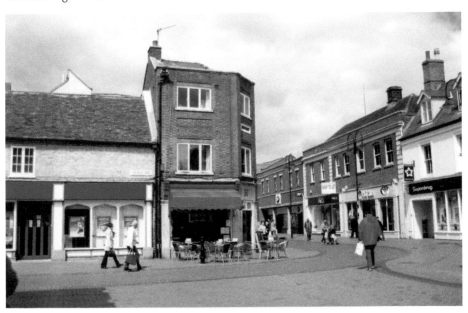

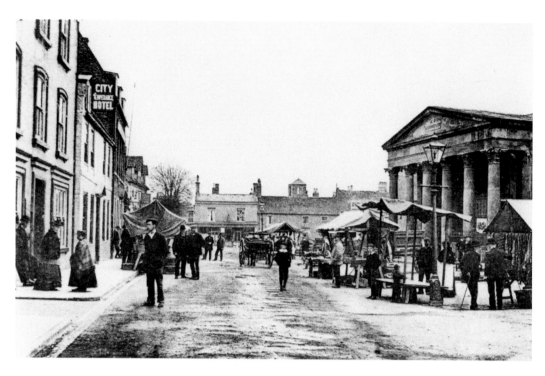

The Corn Exchange with the View to the East

On the left the White Hart and the Temperance Hotel with Nash & Co. General Supply Stores in the distance, but dominating the view from 1847 to the 1960s the pedimented and columned Corn Exchange. Behind buildings on the east side of the Market Place was a small look out tower; there was another lower down Fore Hill. Today's photograph shows a corner of the 1960s shops on the right, at the end of a busy market day.

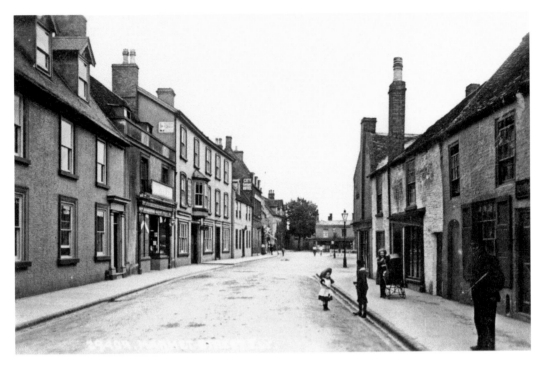

The Market Place with the eastern end of Market Street

A later view again shows the White Hart, the Temperance Hotel with the home of the two Miss Muriels, since the 1930s a fish and chip shop, and Archer House. In 1992 the Market Place was repaved and two plane trees planted near the north-east corner. On the right the Corn Exchange is hidden by Kempton's and, with the tall chimney, Allpress' premises. Nearest the camera, in the mid 1940s, the back of Peck's faced onto Market Street.

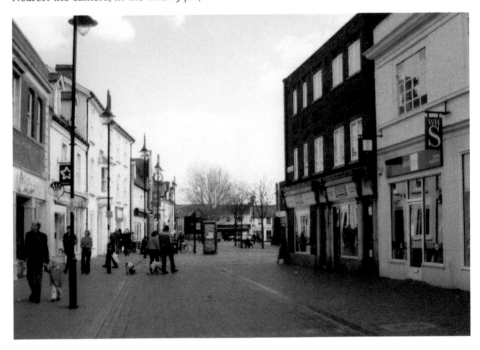

Entry to the Vineyards

On the John Speed map of 1610 there is an indication of an entry to the Vineyards in the north-east corner of the Market Place. In the photograph of about 1986 there are boarded up houses in the centre to the left of Nash's laundry, now part of Cheffins Estate Agents. These houses were demolished in the late 1990s and after a few years replaced by new houses.

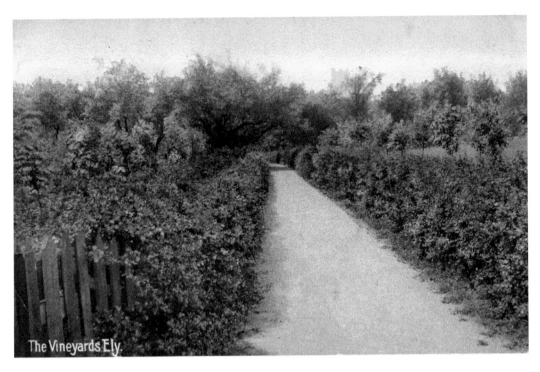

The Vineyards Ely.

The Vineyards, formerly the Bishop of Ely's Vineyard

Over sixty years ago Mr. Long's greenhouses, from which he sold vegetables and other garden produce, were on the left. Today this is a quiet residential area with houses and bungalows on both sides; they were almost entirely built between the two world wars. There is no through road for vehicles though footpaths at the far end lead in two directions.

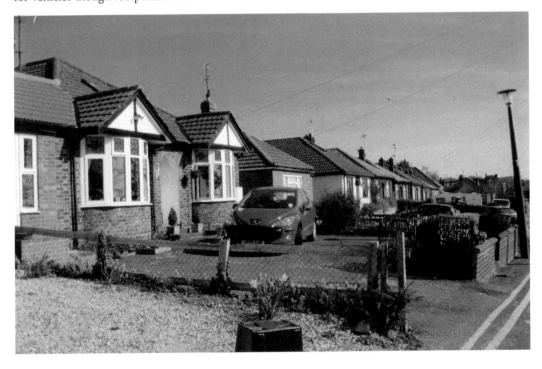

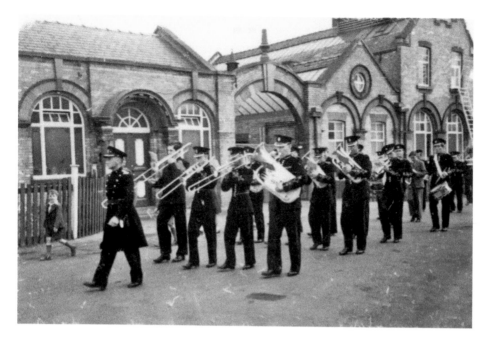

Granger's Fruit Preserving Company: Ely 'Jam Factory'

The British Legion Band, with bandmaster Mr. Currie, parades past the 'Jam Factory' in 1940; they wear smart navy blue uniforms with blue and gold facings. Granger's Fruit Preserving Co. opened in 1890 and within twenty years new buildings were erected. St. Martins (Eastern) Ltd. followed: then after 1959 Dorman Sprayers and later Eastern Counties Printers. The factory was demolished in the 1980s and by 1990 St. Martin's Walk had developed at this end of Bray's Lane.

Toward the small hamlet of Queen Adelaide

On the west side of Prickwillow Road, before Thistle Corner, near the hamlet of Queen Adelaide, there was open farmland until 2006. The water tower in the distance is in the grounds of the former Princess of Wales Royal Air Force Hospital on the Lynn Road. Many houses have now been built behind the hedge, the planned total almost four hundred. The through road that links with Lynn Road and High Barns is expected to be open this year.

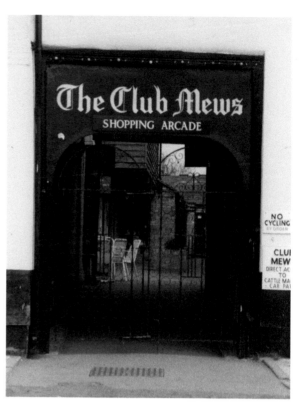

The Club Mews Shopping Arcade
In October 1991 the Club Mews, off the Market Place, opened with a variety of small shops. By 1997 all had closed, soon to make way for The Cloisters. The opening, once an entry to the Club Hotel yard, is now one way from the Market Place into The Cloisters. In 1992 Waitrose opened there soon to be joined by Iceland, Peacock's, and other smaller units which included Ocean Cargoes (moved to High Street 2009), Wilkinson's and in 2000, by Ely Library.

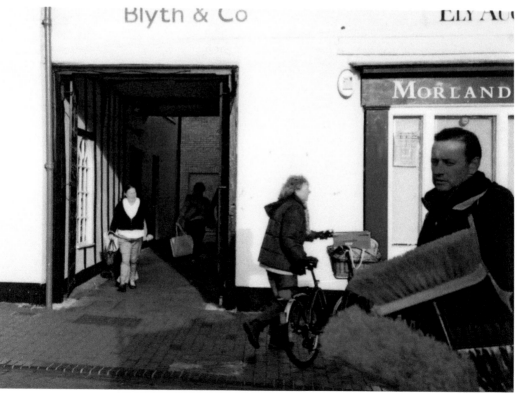

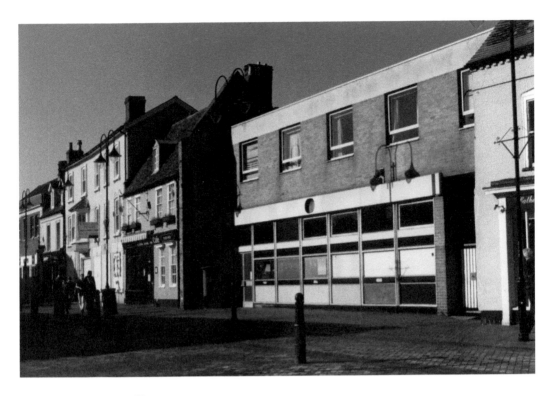

The New Post Office

The Victorian nineteenth-century post office was where the City Cycle Centre is today. A new post office was opened in 1966; both had a sorting office and a delivery yard at the back. Over twenty years later the post office moved to part of a chemist's shop in the High Street where it remains today though it has now been separated from the chemist's premises. In 2009 it became the city's only post office; queues out on the pavement are a common sight.

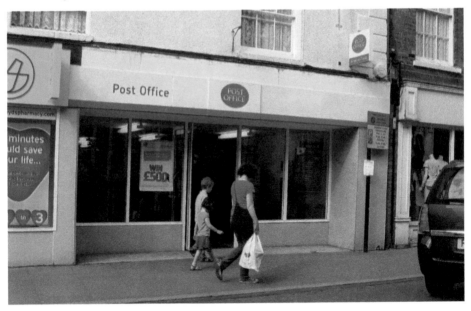

Tesco and Woolworths

On the corner of Bray's Lane, the first Tesco in Ely opened in October 1965. After the earlier photograph the façade was changed to enhance the Market Place. This branch of Tesco closed and later Woolworths moved here from its original site on Fore Hill. The recent photograph was taken on the last trading day in January 2009. It remained empty until the middle of April 2010 when M. & Co. moved from smaller premises two doors away from Boots.

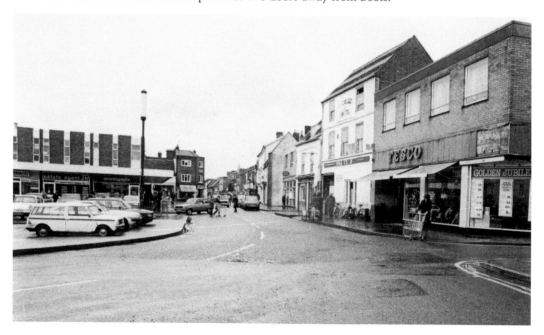

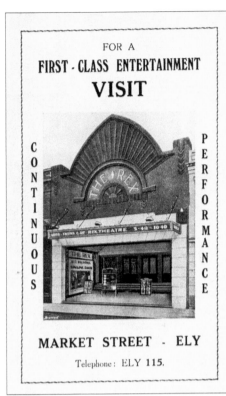

FOR A
FIRST - CLASS ENTERTAINMENT
VISIT

C O N T I N U O U S

P E R F O R M A N C E

MARKET STREET - ELY

Telephone: ELY 115.

The Rex Cinema
The Rex 'Ely's new and ornately decorated cinema will be opened on Monday 22 September 1929'. This advertisement is from a guidebook before the original art-deco front was remodelled in the 1930s. The Rex closed in January 1981 after many films, theatrical performances and other events had taken place there. Boots the Chemists first had a small shop in High Street, then a larger one, before new premises were built in Market Street.

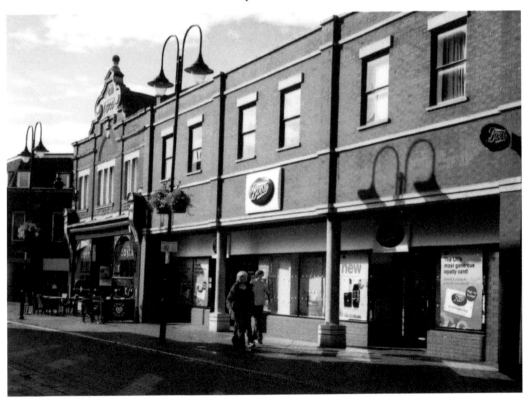

Theatricals

'Watch It Sailor' was performed in 1963 in the Women's Institute Hall that was situated off Newnham Street at the back of a delivery area behind Market Street shops. 'Season's Greetings' was staged at The City of Ely Community College on Downham Road in 2001. In both productions the performers were members of the City of Ely Amateur Dramatic Society and are still easily recognised by older residents.

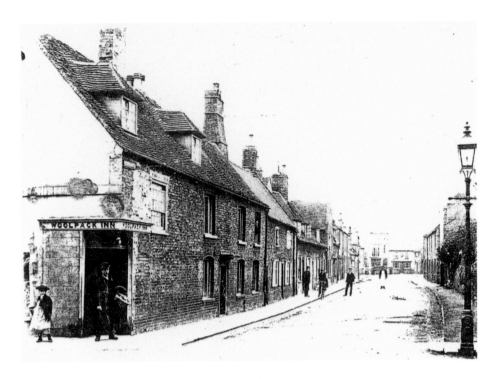

Looking up Newnham Street towards the Atrium

From the mid eighteenth century, or earlier, the Woolpack Inn was on the corner to the left; it closed in 1964 and was demolished in 1971. This building was soon replaced by the solid block of the National Westminster Bank. The small cottages were rebuilt to the same pattern. In the distance Rickward and Sons' furnishing store was transformed into the Atrium Club, a health and fitness centre, in 1992.

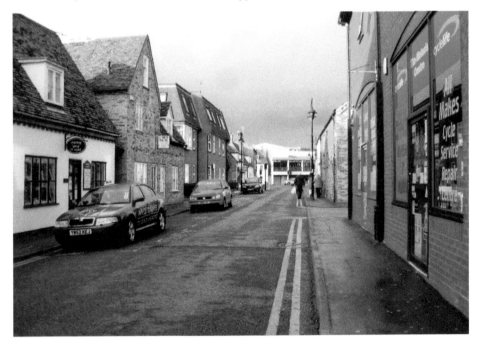

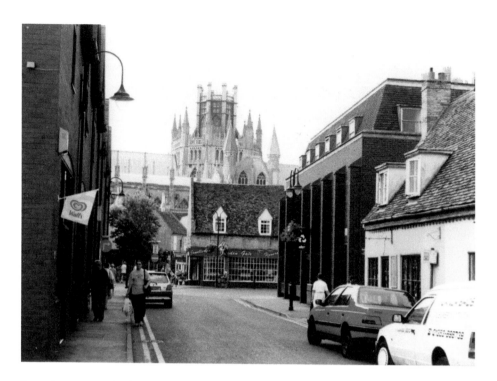

Newnham Street looking toward the Cathedral

Once Bolton's Bazaar, later a shoe shop and then a greengrocer's, this corner was demolished in 2007. A lengthy rebuild, in a style similar to the older building, was completed in 2010. The Cathedral Octagon tower remains unchanged as it has done since the mid eighteenth century work by architect James Essex was largely removed by George Gilbert Scott in the nineteenth century. The National Westminster Bank was built about 1972.

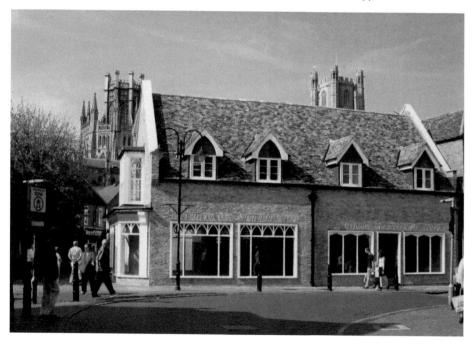

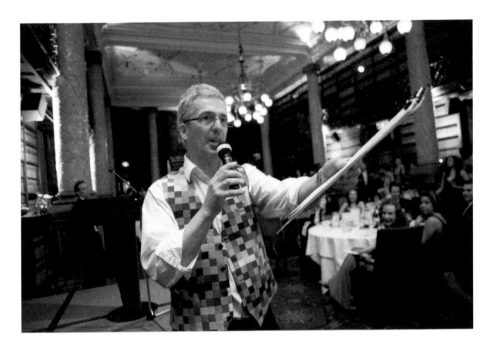

The Cattle Market: George Comins and David Palmer

Cattle were sold on the Market Place until the Cattle Market opened November 1846; one entry was through the carriage archway that now leads into Tindall's stationery shop. Before September 1981 many animals were auctioned here by George Comins, seen on the left. Later all types of goods, from farm produce to furniture, were sold. Waitrose opened here in March 1992. Today, David Palmer, who lives in Ely, auctions goods both here and in venues across the country. Typically, wearing a colourful waistcoat, he is often seen on the television.

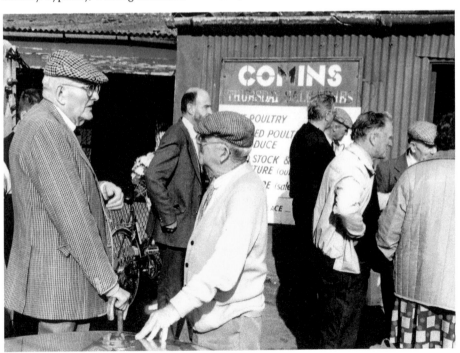

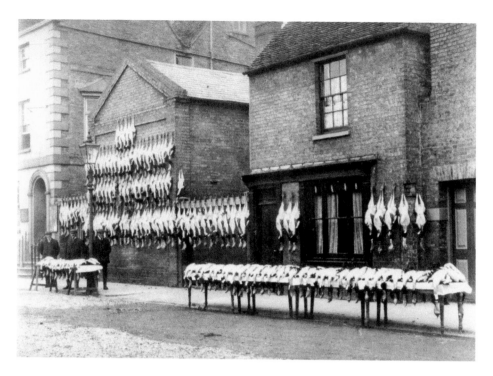

Haylock's Farm in Market Street

The Town House and barber's shop are now on either side of the entrance to Woodbine Haylock's nineteenth-century farmyard. Later his son, Archie, farmed here and travelled to Attleborough annually before Christmas, bought turkeys, drove them onto the train, then up Back Hill to the farm. Cathedral lay clerk and amateur actor Archie also kept cattle that grazed on Dean's Meadow and were driven along Market Street to the milking parlour. Central Hall, on the right, dates from the 1930s.

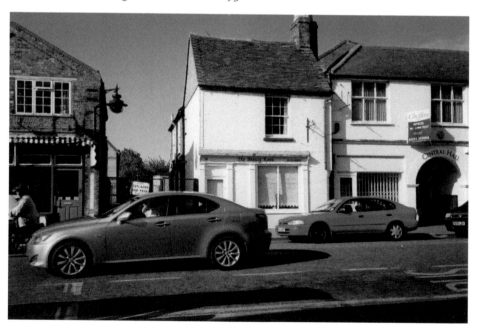

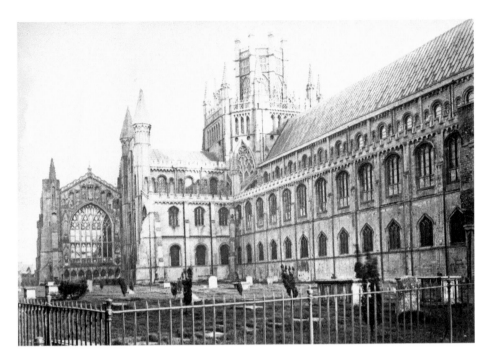

Holy Trinity Parish graveyard now Cross Green early in 2010

Ely's second parish, Holy Cross, was moved into the Lady Chapel in 1566 and renamed Holy Trinity. In 1938 Holy Trinity was united with St. Mary's to form the Parish of Ely. Many of the victims of the 1832 cholera outbreak were interred in this graveyard which by 1855 was full. The remaining memorial stones were cleared in the 1960s. Now a variety of events take place here and many tourists enjoy relaxing in the open space.

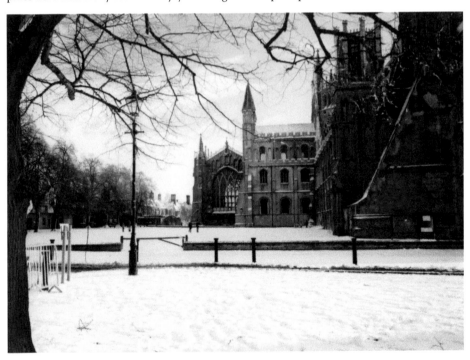

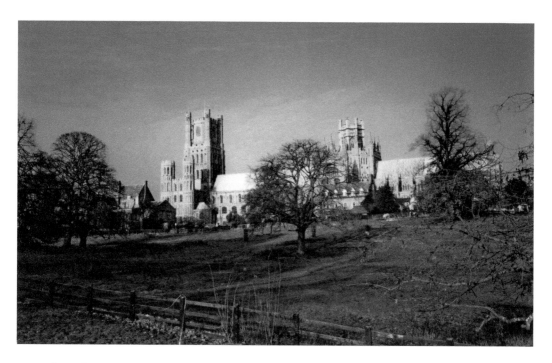

Ely Cathedral drawn by J. M. W. Turner, engraved E. Higham

Perhaps artistic licence but clearly the houses near to the ruined St. Catherine's Chapel in 1833 have gone. The lantern tower shows James Essex's changes again but the sweep of grass and the rest of the Cathedral look much the same today. It is not possible to view the scene exactly as when drawn by Turner as Canonry House does not appear, although the south gable wall of the Black Hostelry is shown, almost hidden by trees in today's photograph.

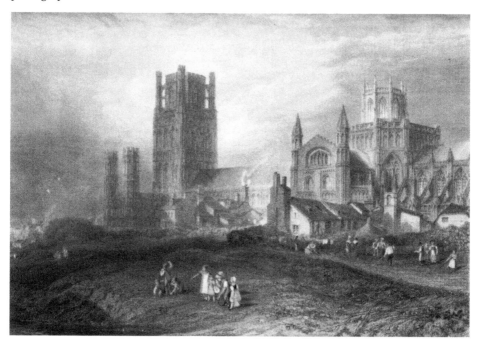

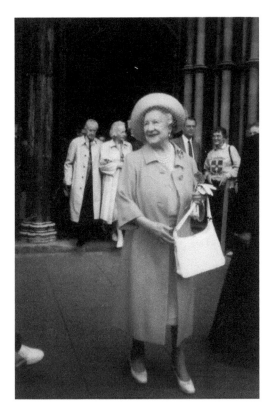

The Queens: the two Elizabeths
Above, Elizabeth, the late Queen Mother,
leaves the Cathedral in June 1988. Below,
Queen Elizabeth II on her fourth official
visit on 19 November 2009 after attending
a short service, accompanied by The
Duke of Edinburgh, to celebrate the nine
hundredth anniversary of the foundation of
the Diocese of Ely in 1109. With her as she
leaves the Cathedral on a very windy day,
is the sixty-eighth Bishop of Ely, Anthony
Russell.

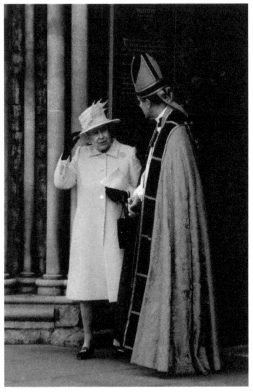

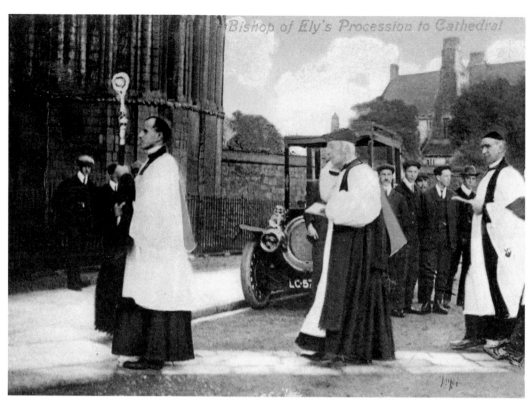

Bishops and Archbishops:
Nine Hundred Years of Ely Diocese
Bishop Frederick Henry Chase (1905-
1924) is verged from The Bishop's Palace
to the west entrance of the Cathedral.
Behind him is probably a Delanney-
Belleville vehicle of the early twentieth
century, perhaps rebuilt. Many years
later Archbishop Rowan Williams
approached the Cathedral south door
with Anthony Russell, to take part
in the commemorative service on 24
January 2009. Celebrations concluded
on 21 November when John Sentamu,
Archbishop of York, provided a focus for
many, mainly young, people who took
part in an afternoon of vibrant activity.

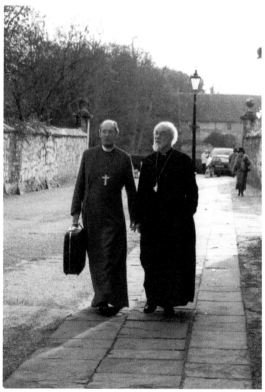

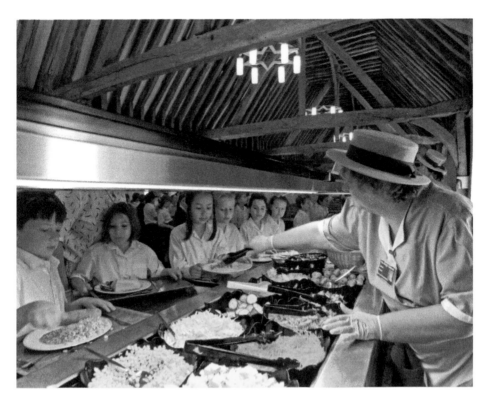

The King's School; interior of the Monastic Barn

The former monastic barn was used during the first half of the twentieth century as a gymnasium, but today provides a fine dining hall used by nine hundred students and staff at lunchtime. Numbering nearly one thousand pupils aged from three to about eighteen years old the school is one of Ely's largest employers. It continues to grow in size and reputation under the present headmistress, Mrs Susan Freestone, who succeeds a long line of headmasters.

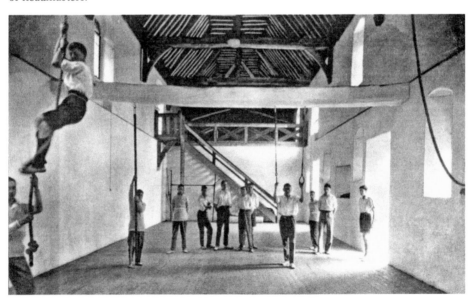

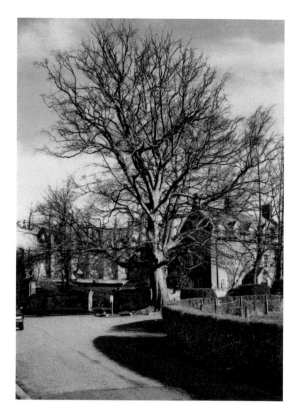

The Beech Tree

This beautiful tree on the east side of the road that leads to the Cathedral south door grew near Canonry House for about two hundred years; it had to be felled in 2009 due to its severely diseased condition. Canonry is a King's Schoolhouse, one of seven in the precincts and City, necessary to house two hundred and fifty boarders. Early in 2010 two old chestnut trees near The Porta were also felled due to disease.

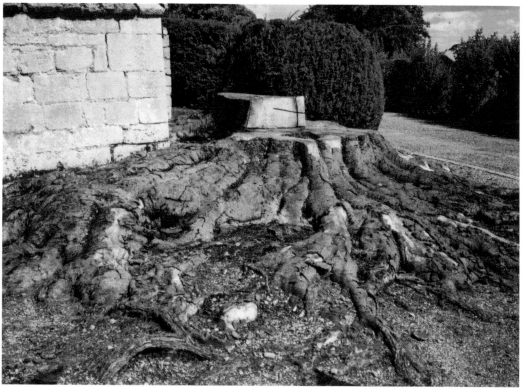

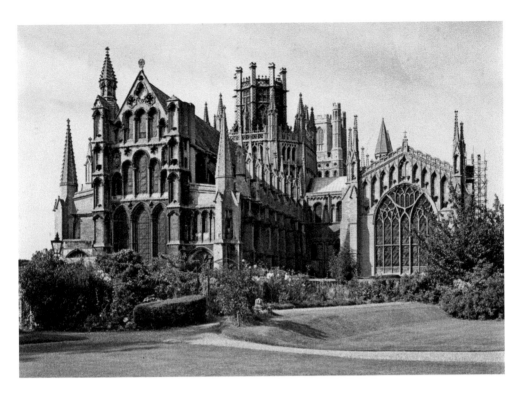

The east end of the Cathedral

Since 2000 there has been an important change in this view; a new Processional Way, that leads from the choir stalls to the Lady Chapel, designed by the Surveyor to the Fabric, Jane Kennedy, has been built on the site of the former medieval passage. Traditional design and materials were used so it fits harmoniously with the medieval architecture of the Cathedral. Railings, a few feet away, protect the ground level windows.

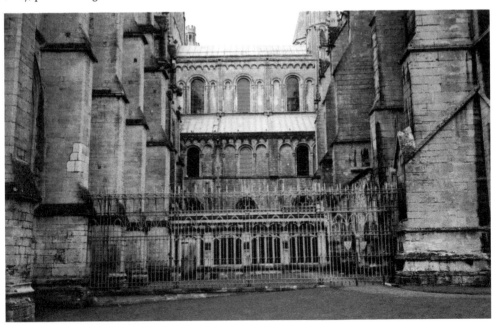

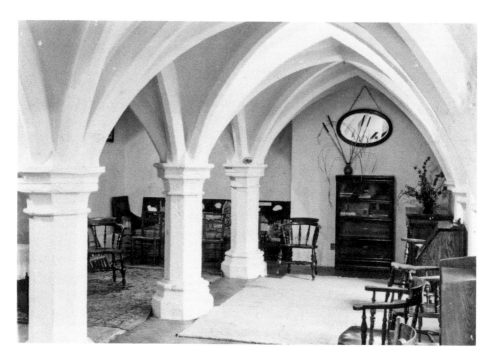

The Almonry Restaurant 1973 and 2009

The home of one of the Cathedral residentiary canons for many years this thirteenth-century undercroft, formerly part of the monastic almonry, was at one time a room used very occasionally for meetings. Following its use as as a home it was converted in 1989 and is now part of the popular Cathedral Almonry Restaurant, the venue for many celebratory gatherings. In July 2009 a special birthday party is taking place.

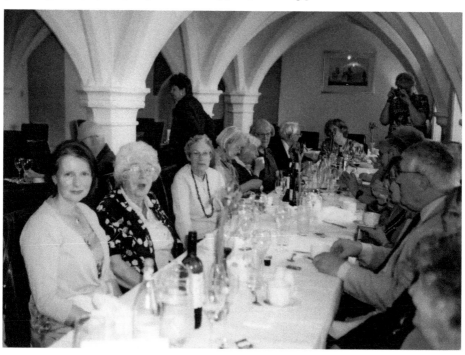

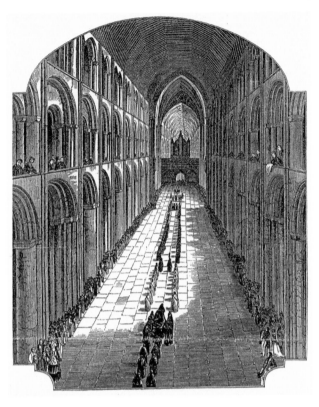

Print of the Funeral of Bishop Allen
The funeral took place in April 1845 'in the presence of a very large concourse of spectators'. The procession included over sixty mourners from the Dean, choristers, and relations to 'Mutes', bricklayers and carpenters. Today's photograph shows not only the absence of the screen, with organ on top, and a clear view to the reredos but also people gathered for a rare event, a banquet in the nave. Held on 14 July 2000 it marked the completion of the late twentieth century's vast programme of restoration and was attended by the Duke of Edinburgh.

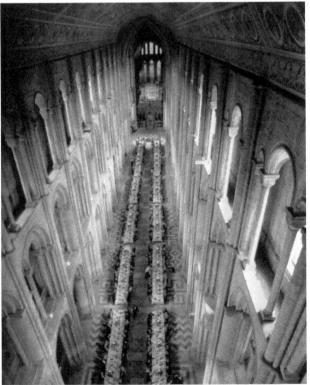

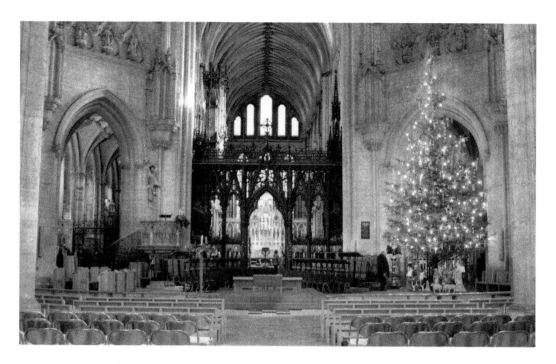

Ely Cathedral, under the Octagon

In the days when wooden benches were provided up to the choir screen many services were held at the high altar. A central altar under the octagon was first used in the 1960s, but a permanent octagon altar, with other furnishings, designed by George Pace has been in use for almost forty years. All large services are held here including the Sunday morning Eucharist. From 1982 a beautifully decorated tree, with Nativity scene below, has been a great attraction at Christmas.

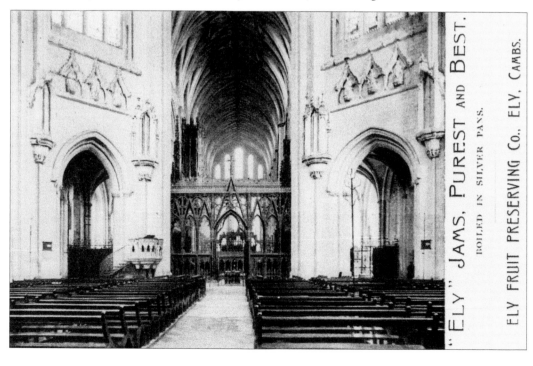

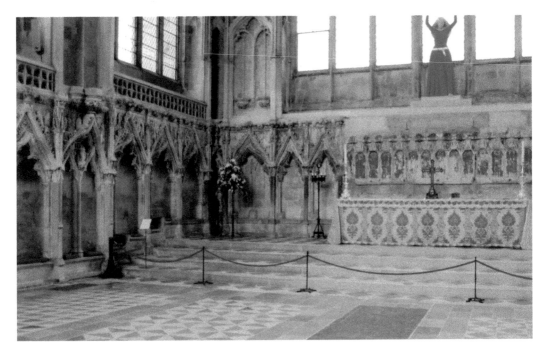

The Lady Chapel: Ely's second parish church 1566 to 1938

Here were parish memorials and many wooden benches with, on the right, a heater for the winter and sunblinds for the summer. Today services, concerts and exhibitions take place under the watchful eye of David Wynne's Portland stone sculpture of Mary which was unveiled by His Royal Highness the Prince of Wales in 2000. Two years later a new floor of Purbeck marble, designed by Jane Kennedy, was dedicated by the Princess Royal. A re-ordering of the east end by John Maddison will further enhance the chapel when completed later this year.

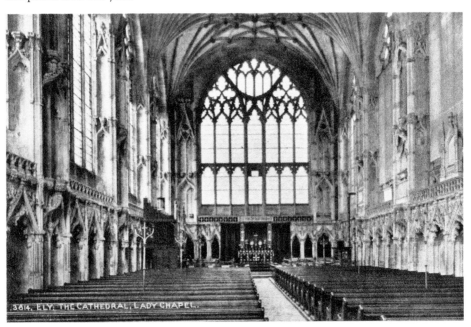

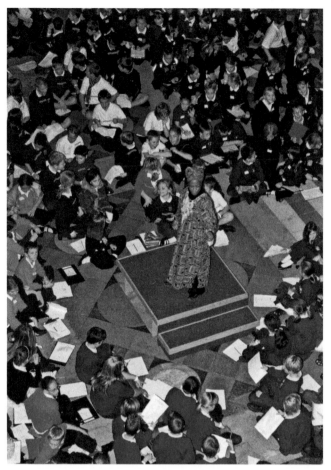

Cathedral Clergy, Organist, Choir and Vergers and a Schools' Day

Only older Ely residents will remember lay clerks Charlie Bush, Nobby Clark, Archie Haylock, choir boys Roy Stubbings, Henry Howell and others with organist Marmaduke Percival Conway. Taken at the time of Dean Kirkpatrick in the early 1930s this contrasts with the photograph of 2008 when hundreds of school children were inspired to sing by Sally Bradey. Four special days for schools take place every autumn in the Cathedral, though many school groups visit throughout the year.

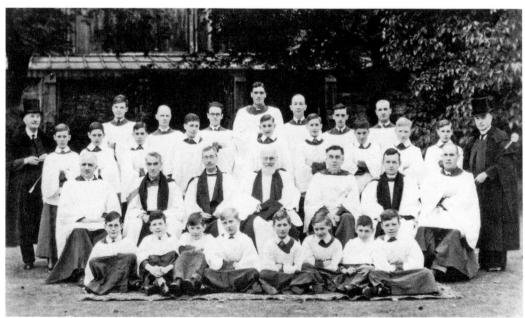

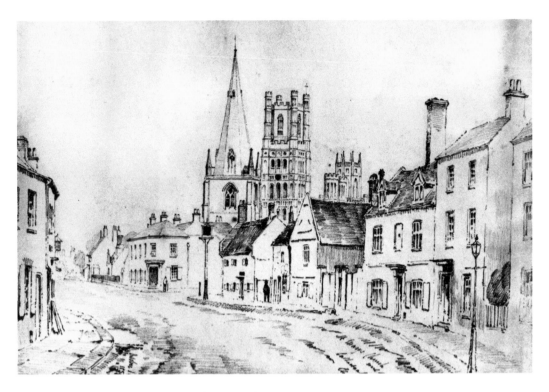

Henry Baines' late 1850s drawing of St. Mary's Street

In the distance the view is familiar apart from the changes to the Lantern Tower. On the right three houses and another building have been replaced, one by a later three-storey house. The 2010 photograph shows a post-war house on the right; it was converted to St Mary's Street Surgery, which opened 4 March 1991.

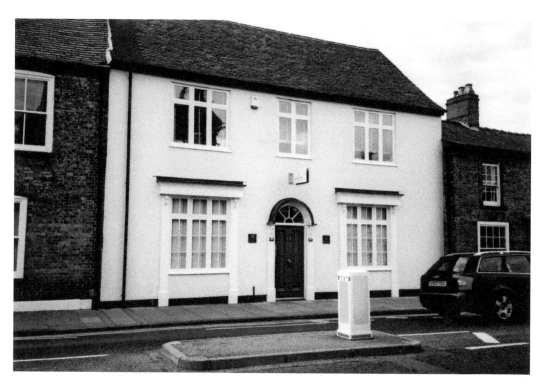

A. C. Lemmon, Butcher's

The building, on the west side of St. Mary's Street, is essentially the same today as with many much older buildings in the City centre, but here in 2009 there was a transformation and change of use at ground floor level. The butcher's shop, after over thirty years of trading, closed in 1986. 'Enhance' which carries out dental and facial regeneration has now opened here.

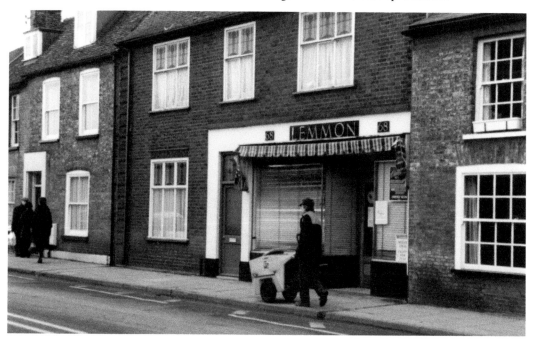

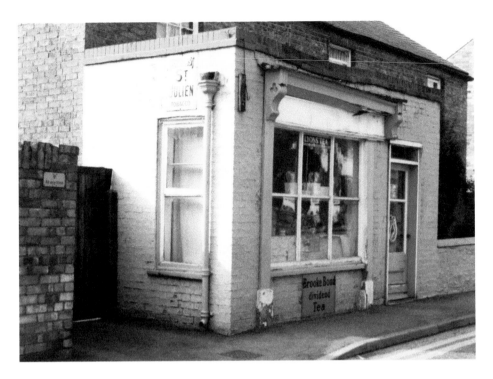

A General Store in Chief's Street

Another example of a ground floor alteration where there had been a shop since the early twentieth century. In the earlier photograph note the two tin advertisements for tea and tobacco still in place after the shop had closed, sometime before 1982. Much of the building to the rear remains as a private house.

The National School in Silver Street

The National School, built by architect Teulon, had the headteacher's house between the boy's section on the left and the girl's to the right. The school was demolished in 1972 and private houses built about five years later. In the distance is the spire of St. Mary's Parish church. Most of the windows and some roof timbers from this school were re-used in the chapel at Bishop Woodford House, the Diocesan Retreat Centre on Barton Road.

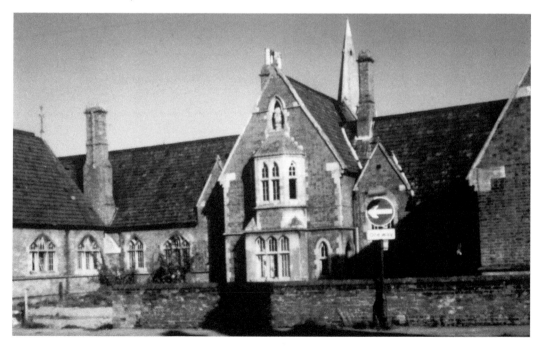

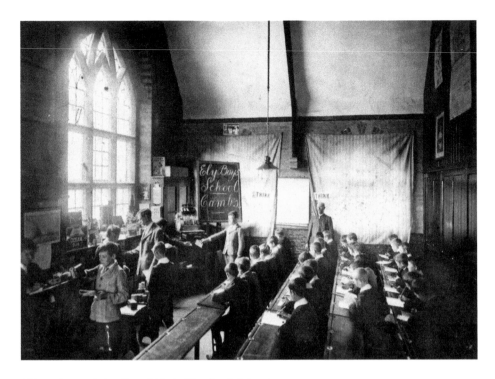

'Silver Street School' and Little Thetford School

The National School in Silver Street probably in the early 1930s when Mr Thrower was headmaster. Some of the boys appear to be pretending to shop. In the earlier large photograph advertisements can be seen for Fry's Cocoa, Ocean Blue, Gipsy Blacklead, Colman's Starch etc. The photograph of July 2009 shows headmaster Robert Letton and Janet Piggot, one of the Friends of the School, with James Paice MP as he opens a new library section at nearby Little Thetford School.

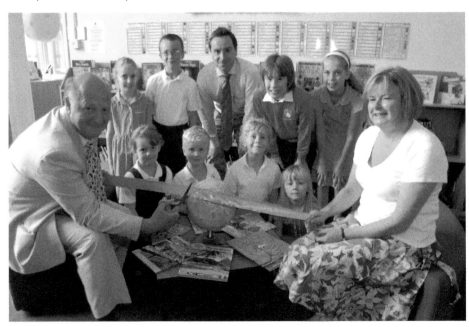

Oliver Cromwell House and the Tourist Information Centre

The house *c.* 1870 after it had ceased to be the Cromwell Arms but still retained a plastered façade. In 1905, before it became St. Mary's Vicarage, the frontage was changed considerably. In 1986 it was bought by the District Council and converted into a Tourist Information Centre which opened in autumn 1990. Nearby there is now a bus shelter, litter bin, post 1955 red telephone kiosk, a new street light with hanging baskets and three BT black 'pillars'.

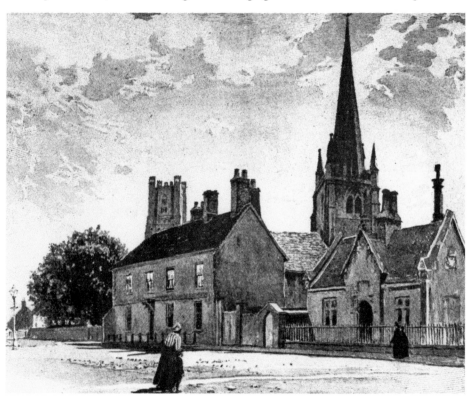

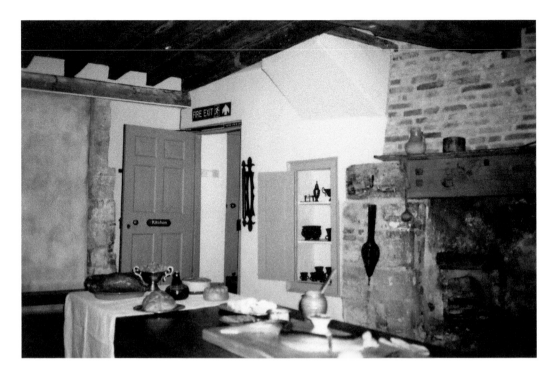

Part of the interior of Oliver Cromwell's House

This was probably Mrs Cromwell's kitchen in the mid-seventeenth century and certainly during the time that it was St. Mary's Vicarage, from 1905 to 1986. It is now set out to show how it might have been when Oliver Cromwell with his mother, wife, two sisters and six children lived here for four or five years from 1636. The family continued to live in Ely for a further five or six years.

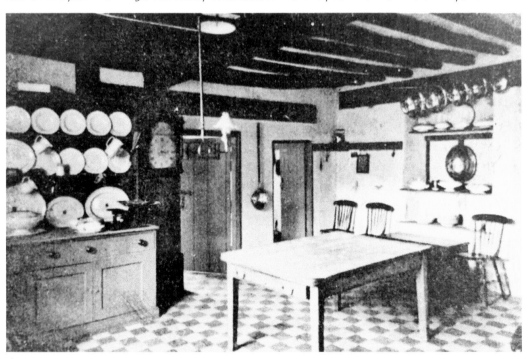

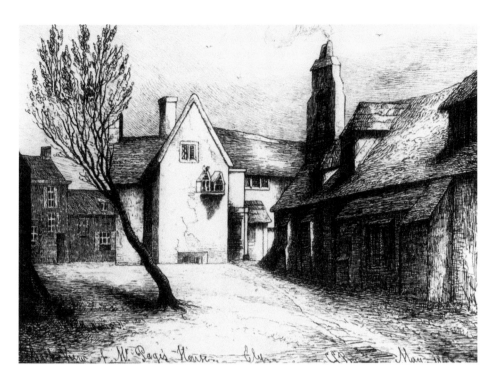

The south wing of Oliver Cromwell's House and the backyard, 1848

Part of the kitchen wing on the right shown as it once extended southwards. Jonathan Page, last farmer of the tithes, lived here until he died in October 1840. The house was auctioned, bought by Joseph Rushbrook and became the Cromwell Arms until 1871. Clearly the houses to the rear of 'Mr. Page's Backyard' have gone even if their existence was not due, originally, to artistic licence. Seen today, beyond the churchyard is part of The Range, off Silver Street.

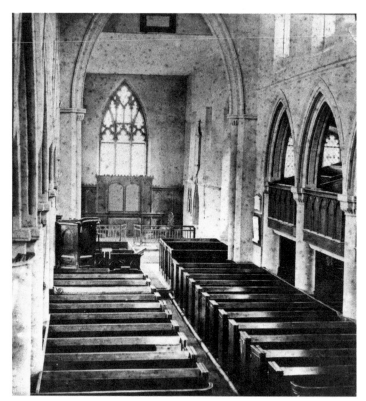

The interior of St. Mary's Church with Gallery
Considerable changes were made in 1876 when the gallery on the right, with two others, was removed. In the 1860s the three-decker pulpit was cut down and taken away in 1879. The old pews were replaced by uncomfortable 'benches of simple and graceful design'. In 2001 the organ from the north aisle was transferred to Haslingfield and the war memorial was moved to the south nave wall. On the south side the Church Room, later enlarged, was opened in 1985.

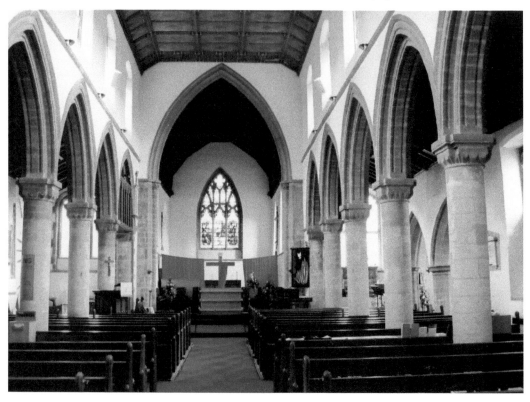

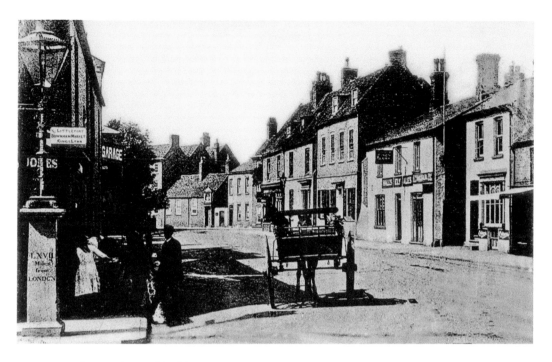

From the Lamb Hotel looking west *c.* 1920

On the right was a barber's shop, the King's Arms and a tall building, once a farmhouse, which was the Electricity Showroom up to the 1970s, now Chic, Face and Body Clinic. The small shop, beyond the former farmhouse, was converted in 1991 back to residential use after many years as a garage showroom. The milepost on the left was knocked down about 1930.

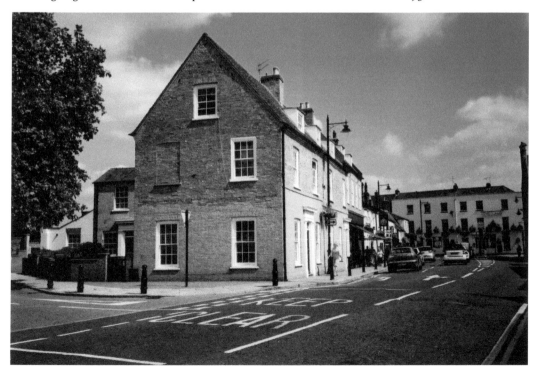

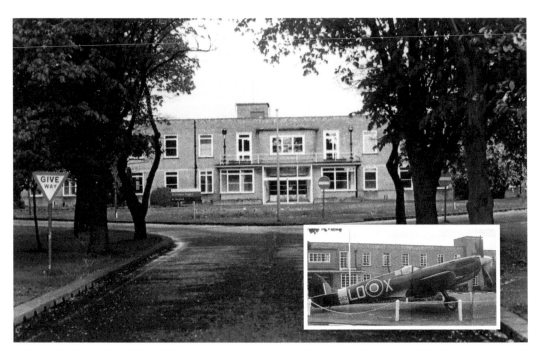

The Royal Air Force Hospital 1940-1992, Lynn Road, Ely

Officially opened in 1940, many of the buildings were demolished after its closure as a Royal Air Force Hospital. The Princess of Wales visited in July 1987; following this her name became part of the hospital's title. Today it is a community hospital known as The Princess of Wales Hospital. For many years a Spitfire was in front of the main entrance, just off the Lynn Road.

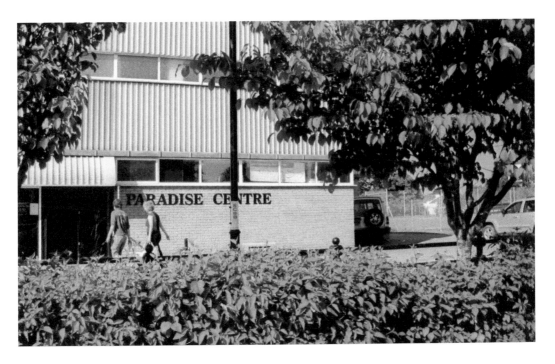

Paradise Field

For many years Paradise Field has been in use for games, including tennis, football and hockey, and for other events. Here annual 'Ely Sports' days took place from 1893 to 1964, except for short breaks during the two world wars. Three cyclists take part in one of a series of sprint races in 1955, on the right the noted champion, Reg Harris. In April 1986 the Paradise Centre opened with two swimming pools and other modern facilities.

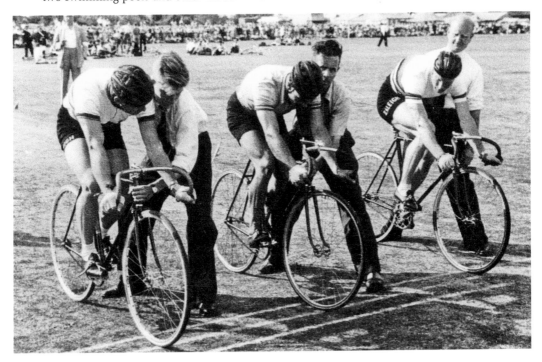

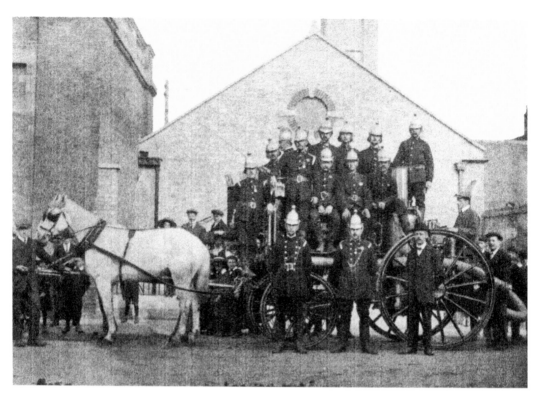

Ely's Firemen

An official brigade was formed in 1904 and in 1912 a building and practice tower were erected on Lynn Road, next to the old Gaol, now Ely Museum. After the Urban District Council built new offices the engine was housed below them. In 1943 a Fire Station, now Ely Community Fire and Rescue Station, was opened in Egremont Street. Firefighters pose for the camera early in the twentieth century and in 2010.

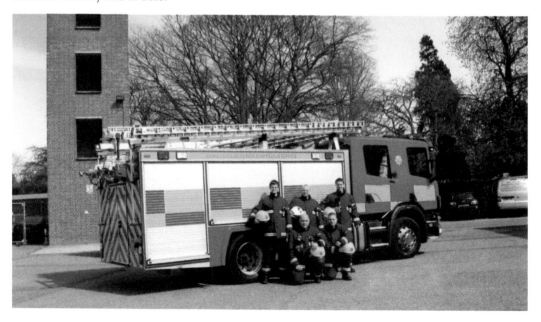

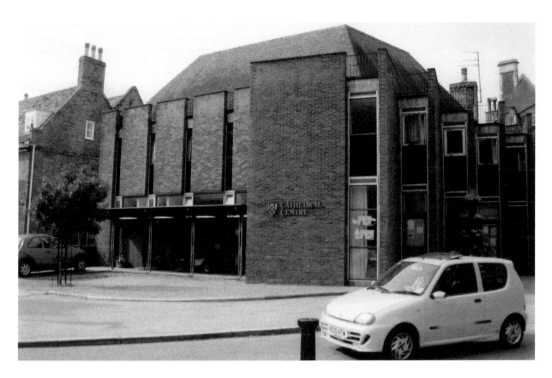

The Minster Tea House on Palace Green

Opened by Vernon Cross before 1935 the Tea House closed during the first years of the Second World War. A bookshop took over this site and nearby premises. In 1966 a library designed by architect Don Roe opened here; the building received a Civic Trust Award. After the present Library in the Cloisters development had opened the building was sold and became The Cathedral Centre in 2000. It is much used by the Cathedral's Education Department and others.

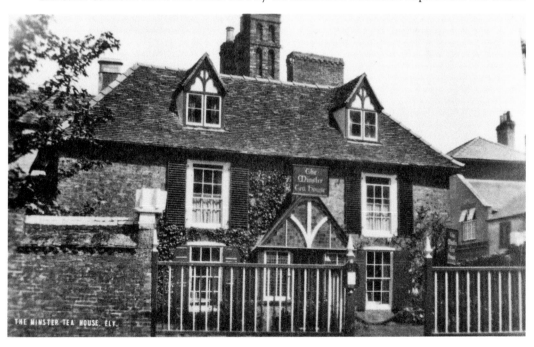

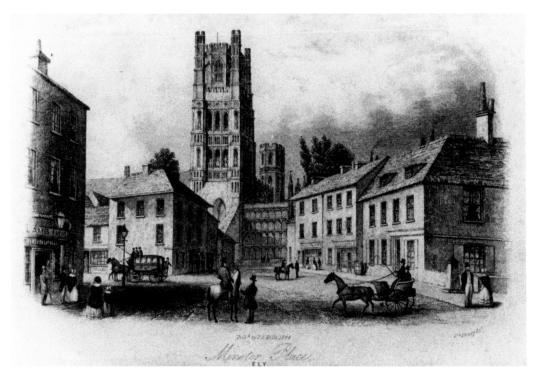

The Lamb Corner in 1848

On the left 'Prudential Corner' and on the far right the Minster Temperance Hotel in front of which the milepost is seen on the extreme right. To the left of the hotel were two shops, Hill's Wine and Hill's Printers. Lloyd's Bank, now Lloyds TSB, was opened on the site of the hotel in 1922.

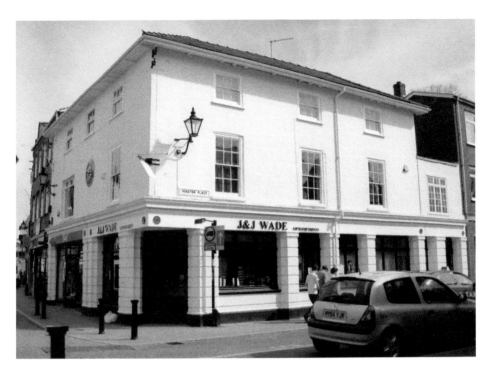

The 'Prudential Corner' now Wade's Optometrists

Known locally as Prudential Corner because it was revamped to provide offices for the Prudential Assurance Company, later for the Norwich Union Fire Insurance Company. Seen with an oriel window the building is covered in posters for Colonel McCalmont who was elected as MP for the Isle of Ely 1900. On the far left the tree is in the yard of Dr. Beckett's House, St. Audrey's, on the south side of High Street.

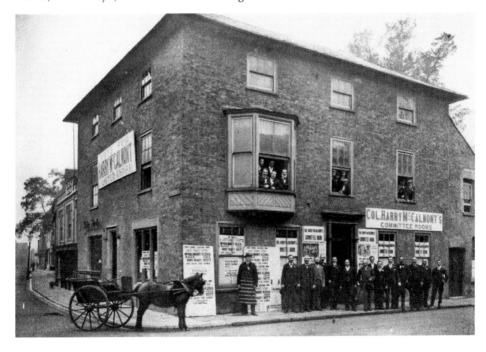

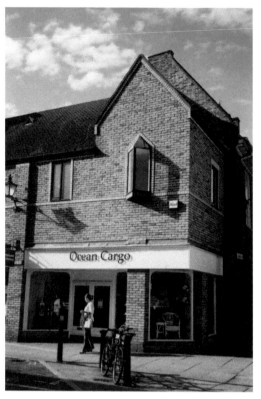

High Street toward the Buttermarket from the Lamb Corner

On the right Hills' insurance premises are clearly seen. On the left was Frank Peake, gentlemen's outfitters, Karen Leslie ladies' underwear (moved to Market Street 2009, closed March 2010), Burrows, Gardiners, chemists, Legge's shoe shop and Pledger's, drapers. On the corner was H. & J. Cutlack ironmonger's, before that section was rebuilt during 1987; Ocean Cargo is now here. On the opposite corner of Chequer Lane Bonnett's, bakers, once County and Country Bank, is now a card shop.

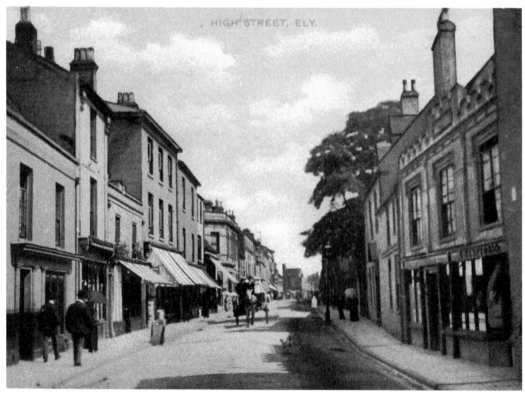

The Pledger and the Chapman Families

Arthur Deer Pledger, founder of the draper's business in High Street, where Argos is today, poses proudly with his wife Louisa and children Hugh, Dorothy, Arthur, George, Mary and Percy in about 1894; then the family lived over the shop. Great grandmother, Frances Plumb, with her daughter, Peggy Chapman, grandson Peter and first great granddaughter, Clare outside 16 Bray's Lane where the Plumb family lived. The houses were demolished to make way for the Waitrose car park.

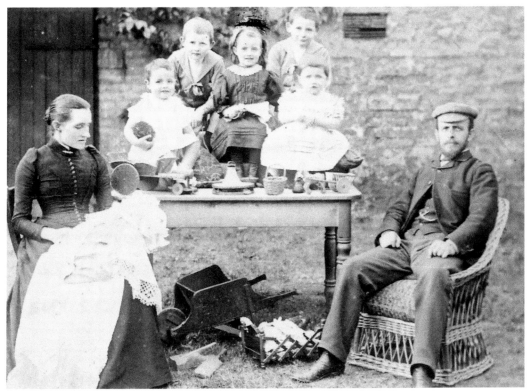

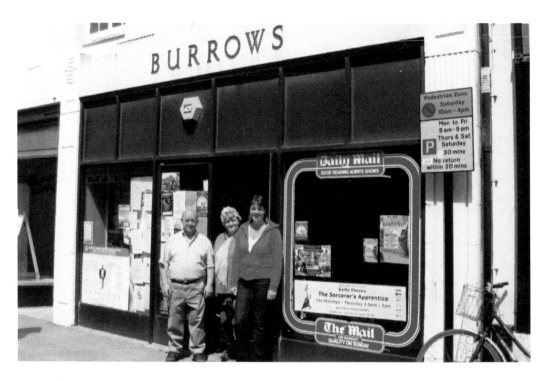

Burrow's Newsagent's in High Street

After eight years on the Market Place the business moved near to Steeple Gate where it remained for about twenty-three years before a final move to number one High Street. During the 1920s the same family apparently had a business in St. Mary's Street, on the corner with Cromwell Road. Today, members of the family, Geoff Burrows, Ann Dix and Annabel Reddick pose outside the newsagent's; the family also run a bookshop in High Street Passage.

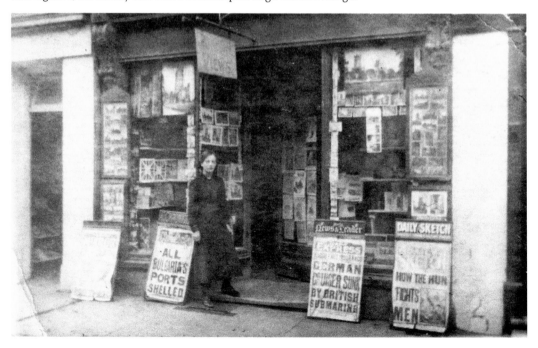

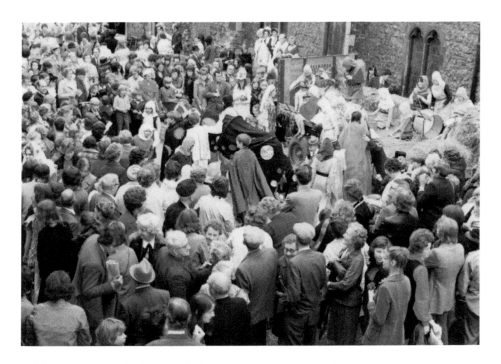

Celebrations to Mark the Foundation of the Monastery in 673

The thirteenth centenary was a wonderful year in Ely. Many celebrations took place, street festivals, concerts, exhibitions, and Ely won the TV game *It's a KnockOut!* In November the Queen's visit was followed, in 1974, by the issue of a Royal Warrant that officially declared Ely a City. On 24 April 2009 an Eel Day procession in the High Street commemorates the plentiful supply once found in nearby waters; eels were used as rent payable to the monastery in medieval times.

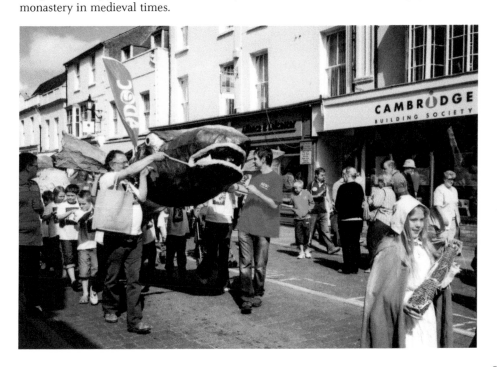

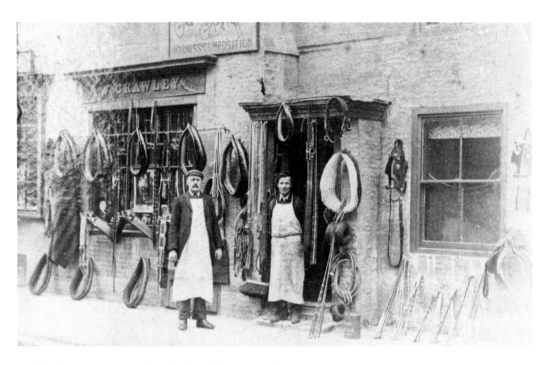

W. Crawley, Harness Makers in the High Street, about 1902

These premises were rebuilt by 1940 and opened as the Trustee Savings Bank until it changed to Lloyds TSB. The bank closed and Prezzo's Italian restaurant now occupies the whole site, though after Crawley's ceased smaller businesses including Madame Berkell, hairdresser's were situated here. Recently an ecumenical procession, organised annually by Ely Churches Together, passes along the High Street.

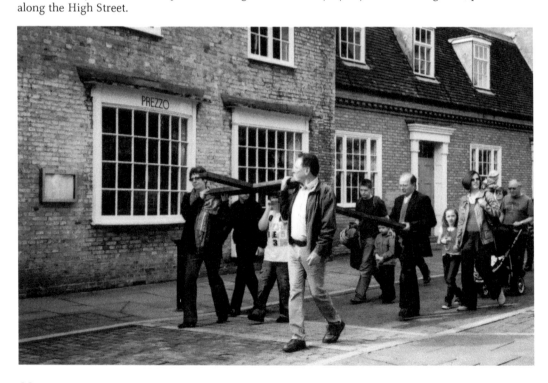

Steeple Gate, High Street;
entry to Cross Green, former graveyard
The history of a building here goes back to
before 1417. Today's building is of various
dates and its occupants included Giscard,
watch and clockseller, a butcher, a florist and
a chemist. In 1978 John Ambrose restored
the building and opened a teashop and craft
shop; by early 2009 the business had closed.
The property was purchased by the Dean
and Chapter of Ely Cathedral. Through the
archway, from Cross Green, a large display of
colourful plants is seen.

Barclay's Bank next to Goldsmith's Tower
A bank may have been on the site as early as the end of the eighteenth century Barclay's Bank opened in two small houses probably before 1920. On the left is the adjoining Goldsmith's Tower once used as the belfry for Holy Trinity Church. To the east side of the tower there was an opening, Church Way, that led to The College as the Cathedral precincts are known in Ely. The exact date of the present premises remains elusive.

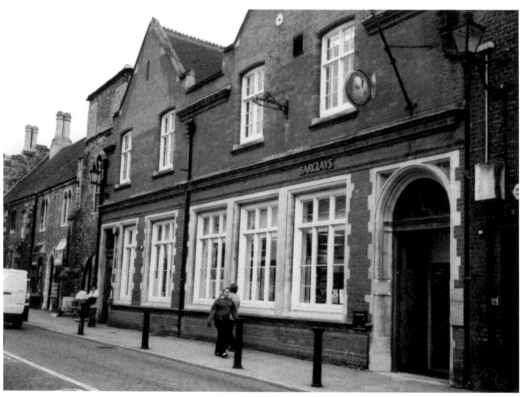

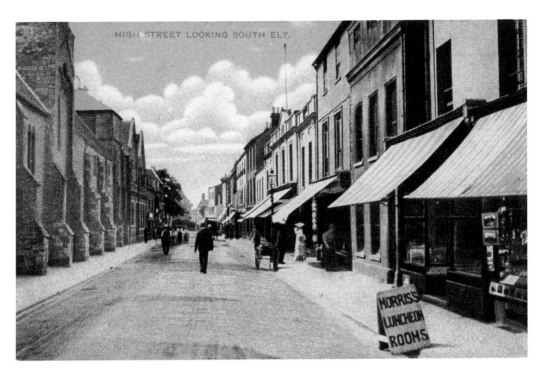

High Street looking toward the Lamb Corner in 1848
On the left is part of the range of buildings that form the northern boundary of the former monastic area, further along is Barclay's Bank. On the right the buildings remain much the same today but two windows on the upper floors of Hughes Electrical Ltd. have been changed, part of Cutlack's has been rebuilt and Peck's, now Pizza Express, has lost its interesting window.

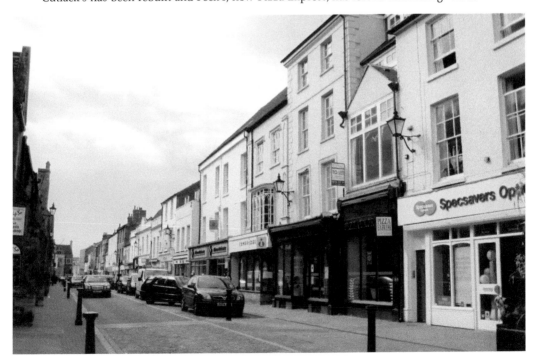

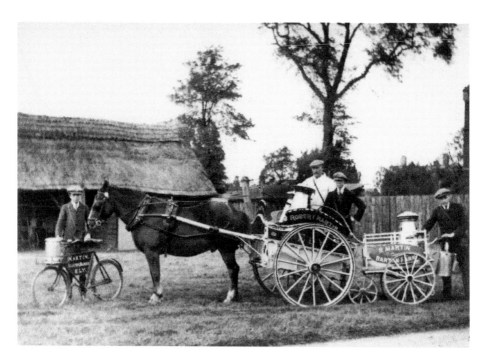

Delivering Milk from Robert Martin's Barton Farm

The Martin family, who pose here, ran their farm and delivered milk. This was taken from a churn and put into the customer's jug at each house. Delivery to individual houses is still possible though not, of course, directly from a farm, and is considerably more expensive than that bought from a shop. Two firms which provide this service locally also offer a variety of other drinks and edibles. Today, a milkman, who travels in an electric van, delivers milk in a bottle.

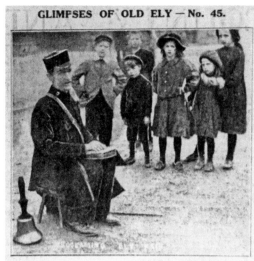

GLIMPSES OF OLD ELY — No. 45.

The late Mr. R. Wayman, for many years Ely's blind town crier, is seen in this picture, sitting on a stool on the Quayside at seven o'clock one morning, in the year 1908, proclaiming open Ely fair. Mrs. J. J. Royal, of 53, Broad-street, Ely, by whom the photograph was loaned to us, is not certain whether it was the May or October fair. Standing at the back is Master George Royal (now deceased) and, in front, reading from left to right, are: Albert Royal, Reginald Peel, Dolly Royal, Elsie Fyson, and Milly Fyson.

Town Criers

Blind Mr Wayman, town crier, sits on a stool at Quayside in 1908 to proclaim the opening of Ely Fair. Chimney sweep Mr Ankin followed later in this office; his uniform included a cocked hat with ostrich feather. Avril Haytor, a member of the Loyal Corporation of Town Criers and of the Ancient and Honorable Guild of Town Criers, has been in full cry since 2001. Here she is seen about to give a talk at Ely Museum.

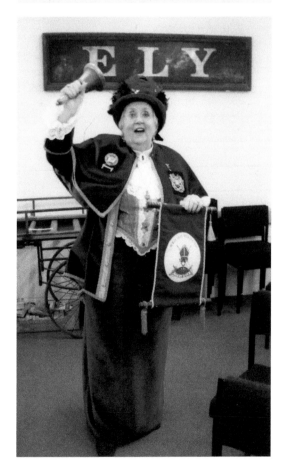

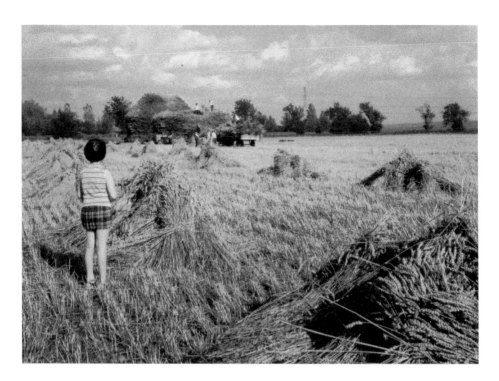

Harvest near Ely

An unbelievably nostalgic view of a harvest scene with haystacks and stooks in a field, within Ely Parish, near the small hamlet of Stuntney. Today, a huge combine harvester sweeps through the field. A tractor and trailer will collect the grain and the straw may be kept, in compact blocks, for later use as bedding or food for cattle. If the crop is barley it may be used in beer making.

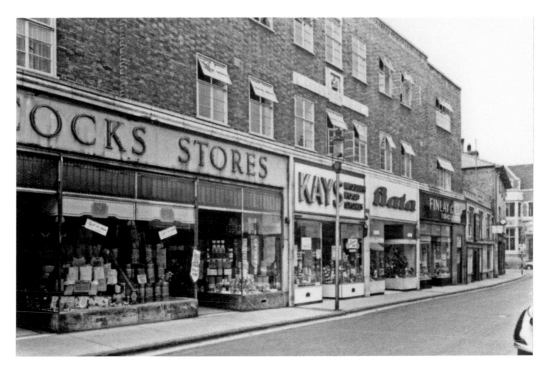

Coronation Parade

This block of shops and offices were built in 1936, on the site of Dr Beckett's home and surgery, to mark the coronation of George V. Today's photograph reflects changes of use and styles of shop fronts, particularly those of Holland & Barrett and Cancer Research UK. The former is a health food shop, the latter one of five shops in Ely that support various charities. Both types were unheard of in the 1930s but are quite common today.

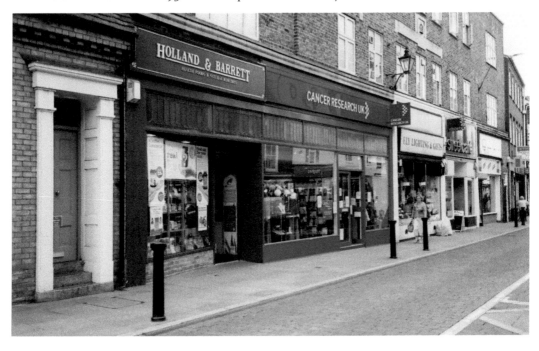

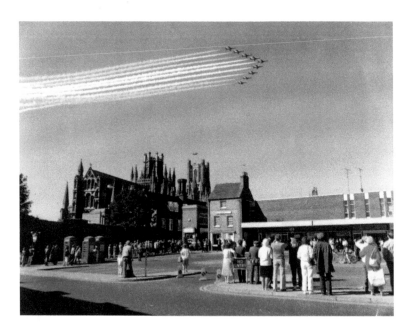

The Red Arrows over the Market Place, 26 September 1987
In 1977 the regiment based at The Princess of Wales Royal Air Force Hospital was granted the Freedom of the City of Ely. This photograph shows the Market Place, with by now familiar buildings and a clear view of the 1960s shops (note too the three red telephone kiosks on the left). This spectacular view of the flypass of the famous Red Arrows, caught by Brian Lane, was to mark the first occasion when the regiment exercised its right to march through Ely.

Acknowledgements

My grateful thanks to all those who have assisted in many ways to make this publication possible with especial thanks to Chris Holley for technical assistance, Marianne Edson, Sarah Flight and Barbara Shailes for helpful advice, and many others for information including Anita Brown, and the following for the use of photographs:

The Dean and Chapter of Ely Cathedral, the Cambridgeshire Collection (page 95), the *Cambridge Evening News* (page 79), Ely Community Fire and Rescue Service, the King's School, Peter Chapman, John Clarke, Ann Dix, Keith Dolby, Geoff Durrant E.C.D.C. (page 15), John Dyal, Ben Green, John Grant, Margaret Haylock, Mary Howell, Fokrul Islam (page 54), Beth and Brian Lane, Joan Lemmon, Robert Letton, Graeme Lockhart, the Lunch Box, Donald Monk, Les Oakey, David Palmer, Richard Pledger, Michael Rouse, Sue Thompson, Carol Trigg, Warren Trotter, the Trustees of Ely Museum and Jeremy Tyrell.